T0352782

Existence

A STORY

David Hinton

SHAMBHALA

Shambhala Publications, Inc.
2129 13th Street
Boulder, Colorado 80302
www.shambhala.com

© 2016 by David Hinton

All rights reserved. No part of this book may be
reproduced in any form or by any means, electronic
or mechanical, including photocopying, recording, or
by any information storage and retrieval system, without
permission in writing from the publisher.

9 8 7 6 5 4 3

Printed in the United States of America

Shambhala Publications makes every effort to print
on acid-free, recycled paper.
Shambhala Publications is distributed worldwide by
Penguin Random House, Inc., and its subsidiaries.

Designed by Steve Dyer

Library of Congress Cataloging-in-Publication Data
Names: Hinton, David, 1954—author.
Title: Existence: a story / David Hinton.
Description: First Edition. | Boulder: Shambhala, 2016
Identifiers: LCCN 2015047462 | ISBN 9781611803389 (pbk.: alk. paper)
Subjects: LCSH: Philosophy, Chinese. | China—Religion. | Wisdom. |
Shitao, active 17th century–18th century—Themes, motives. |
Cosmology. | Ontology. | Consciousness.
Classification: LCC B5232 .H56 2016 | DDC 181/.11—DC23 LC record
available at http://lccn.loc.gov/2015047462

Existence

1

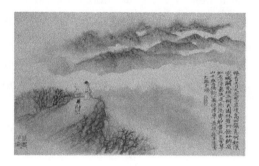

THIS IS THE STORY of existence, and it begins with a painting. Like countless other paintings in the Chinese tradition, this painting by Shih T'ao (see the first page of this book) appears at first glance to show someone gazing into a landscape, an artist-intellectual accompanied by his attendant. But mysterious dimensions quickly reveal themselves, suggesting there is much more here than meets the eye. The poem inscribed on the painting describes a landscape that includes ruins

of city walls and houses, abandoned orchards and gardens, but there is no sign of such things in the painting. The painting's visible landscape isn't realistic at all. It feels infused with mystery: depths of pale ink wash; black lines blurred, smeared, bleeding; mountains dissolving into faint blue haze. And there's so much empty space in the composition, so much mist and sky. This sense of empty space is expanded dramatically by the soaring perspective: the mountain ranges appearing one beyond another suggest the gazer is standing on a mountaintop of impossible heights. And he seems a part of that emptiness, his body the same texture and color as the haze suffusing mountain valleys. Finally, there is the suggestion that the image is somehow a rendering of the gazer's mind, an interior landscape we may possibly share when looking attentively at the painting. Or perhaps that the gazer has returned to some kind of originary place where mountains are welling up into existence for the first time, alive and writhing with primeval energy? Perhaps both at the same time: an originary place indistinguishable from the gazer's mind, and even indistinguishable from our own minds?

There's mystery everywhere in this painting because it isn't a painting about someone gazing into a beautiful landscape, as it might appear. It is, instead, a painting about existence, about our open and immediate experience of existence itself. All of Chinese spirituality and art is grounded in this experience. Poetry, calligraphy, painting, Taoist philosophy, Ch'an (Zen) Buddhist practice: as we

will see, they tell the story of existence, and at the same time, they are spiritual practices that return us to an immediate experience of existence as a cosmological tissue. Mountain landscape itself offered another form of spiritual practice, a practice that incorporates all the others and is the deep philosophical subject of Shih T'ao's painting.

Artist-intellectuals found their spiritual home in mountains, thought of mountains as their teachers, and so mountain landscape was the most natural site for the spiritual practices of artist-intellectuals. They lived as much as possible in cultivated reclusion among mountains, where they also built monasteries. They practiced Ch'an meditation among mountains, either alone at home or with companions in monasteries. They wandered mountains, often lingering on summits as in the painting. They dreamed mountains, and built their creative lives around them. Indeed, rather than an expanse of physical terrain, they saw in the wild forms of mountain landscape the very workings of the Cosmos.

Millennia of Chinese culture's spiritual and artistic insight, Shih T'ao's lifetime of landscape practice: if we could distill all of that into the moment portrayed in this painting (a moment we are invited to share, for we *are* meant to identify with the gazer, aren't we?), it would look something like this: We walk to a mountaintop, face out across ridgeline beyond ridgeline, then close our eyes. We forget everything we know, all of the ideas and knowledge and assumptions about ourselves and the nature of things, all of the thoughts and memories defining us each

as a center of identity. We turn to the empty darkness of pure awareness, which is all that remains after this practice of forgetfulness, and we inhabit the expansive space of that darkness.

Since its origins in the ancient Greek and Judeo-Christian traditions, mainstream Western philosophy has generally taken as its starting point the center of memory and speculative thought, that center of identity that we have just emptied away. Descartes' radical skepticism, for instance, by which he stripped away everything that could be doubted until he found a beginning place: that which is incontrovertibly true. And what he found was thought and self-identity, the timeless Christian soul: "I think, therefore I am." This kind of approach invested Western philosophy from the beginning with an assumption that consciousness is fundamentally different from the empirical realm of existence, an assumption that shaped every level of experience, as we will see; and that assumption led to a preoccupation with otherworldly metaphysics and the seemingly timeless verities of abstract ideas.

But China's ancient sages assumed that this immediate experience of empty awareness was the beginning place, that dwelling here in the beginning, free of thought and identity, is where we are most fundamentally ourselves, and also where deep insight into the nature of consciousness and reality logically begins. It is a place outside the normal human framework, and Shih T'ao's painting establishes this perspective in an extreme and literal sense: it describes a person isolated and far from home and civilization, stand-

ing near the ruins of an ancient city with its abandoned houses and gardens. But you can begin at the beginning anytime, anywhere. A simple room, for instance, morning sunlight through windows lighting the floor; a sidewalk cafe, empty wine glass on the table, trees rustling in a slight breeze, sunlit passersby; a routine walk through a park, late-autumn trees bare, rain clattering in fallen leaves.

Distilling that practice of forgetfulness further, eyes closed, forgetting and forgetting, emptying our minds completely, we turn to the empty darkness that is our own awareness in and of itself. We inhabit the expansive space of that darkness for a time, then open our eyes. We gaze out as if it were sight seeing for the first time, gaze with no expectations at all about the nature of consciousness and reality, wanting to see them as they are in and of themselves, free of all our tenuous human stories about them, our ideas and beliefs. This is, in a sense, the moment portrayed in the painting, and in it we encounter a revelation altogether unexpected and unimaginable: existence! Existence miraculously and inexplicably here when there might just as well be nothing! The sheer presence of materiality—vast and deep, everything and everywhere!

There were in ancient China many conceptual schemes used to approach the deep nature of this existence. One of the most fundamental of these schemes is the distinction between heaven and earth. Heaven and earth are the embodiment of *yang* (male) and *yin* (female) on a cosmic scale, and their interaction generates the perpetual

transformation that is the life of the Cosmos. This Cosmos is the Cosmos of our immediate experience, and if we don't think of heaven and earth as mere abstractions, we can see that heaven and earth are indeed an accurate description of the physical reality in which we live. The generative life-supporting reality of earth requires the infusion of energies from heaven, energies that evolve through annual patterns creating the seasons: sunlight, rain, snow, air. Indeed, as we now know, earth is made of heaven's scattering of stardust, and will again become heaven when our sun explodes into a nebula that engulfs earth, turning it into stardust. We dwell in our everyday lives at the origin place where this vital intermingling of heaven and earth takes place, at the center of a dynamic cocoon of cosmic energy, an all-encompassing generative present, but we are rarely aware of this wondrous fact.

Reinvigorating our awareness of that wonder is one purpose of Chinese landscape painting as a spiritual practice. This explains the primacy of mountain landscape in the tradition, for mountain landscape is where existence itself is most dramatically present as a cosmology of elemental forces, where the intermingling of heaven and earth is most immediately visible. In mountains, one can see earth rising up into heaven, and heaven seething down into earth in the form of dramatic sunlight and mist and stormy skies. And so, ancient artist-intellectuals saw in the wild forms of mountain landscape the workings of the Cosmos not as abstraction, but at the intimate level of immediate experience. As it is where existence reveals

its most dramatically cosmological dimensions, mountain landscape opens consciousness most fully to the depths of those dimensions. There are, therefore, countless Chinese paintings of mountain landscape, and very often they include figures gazing out at lakes, cliffs, blossoms, moons, empty skies, rivers. Or most likely, as in the Shih T'ao painting: gazing out at mountains.

Shih T'ao was himself a restless wanderer and climber of mountains. He lived in the aftermath of the "barbarian" takeover that brought vast destruction and an end to the Ming Dynasty, and his paintings were often autobiographical. So we might assume that this painting,* with its mountains and ruined city, is of Shih T'ao himself. And in the deepest artistic sense it is. But more literally, it is a painting of Shih T'ao's friend Huang Yan-lü. A poet completely forgotten except for his association with Shih T'ao, Huang Yan-lü adopted the personal name Yan-lü, meaning Inkstone-Wander, because of his devotion to travel and writing (inkstones were used to grind ink for writing with a brush). After the fall of the Ming, many artist-intellectuals remained loyal to the Ming and the lost ideal of native Chinese rule. Inkstone-Wander and Shih T'ao were among them. As an act of resistance, Inkstone-Wander took a long journey visiting many sites famous in the struggles against foreign invaders that conquered the Ming Dynasty and, half a millennium earlier, the Sung Dynasty.

* For detailed information about this little-known painting, grateful acknowledgment is made to Jonathan Hay and his *Shitao: Painting and Modernity in Early Qing China*.

Inkstone-Wander commissioned Shih T'ao to paint those sites, and to inscribe on each painting the poem Inkstone-Wander wrote at that site. For Shih T'ao, it was an opportunity to express his own disdain for the foreign usurpers and sorrow at the lost Ming Dynasty.

But it was even more a chance to deepen his art as spiritual practice a little more, for underlying this painting's political dimension is its more fundamental spiritual dimension: a figure gazing out at mountains, taking in their teachings. In painting Inkstone-Wander, Shih T'ao was painting his own political sentiments; but even more, he was painting the wisdom that has come from a lifetime of landscape practice. So at this spiritual level, the figure is more Shih T'ao than Inkstone-Wander. And we too are clearly meant to identify with the figure, to gaze into landscape with the clarity he seems to have, a clarity cultivated through spiritual practices that involved mountain landscape.

That clarity is a beginning place, and almost as soon as this empty gaze into the nature of things reveals existence vast and deep, it reveals something else no less wondrous and unimaginable: there is no distinction between empty awareness and the expansive presence of existence. They are whole, a single existential tissue, which is to say that existence-tissue is our most fundamental self. Mountain ridgelines, mist, winter-charred trees: it's magic, isn't it, the way existence opens through our eyes into awareness, filling us with its form and space? Magic the way there is no distinction between inside and outside, no *I* separate

from everything else (though in describing it, our language insists on that separation)? Here in the beginning, there is this existence-tissue open to itself, miraculously and inexplicably aware of itself, when there might just as well be nothing but opaque existence, existence blind to itself! Vast and deep, everything and everywhere—the sheer presence of materiality is open to itself through our eyes, aware of itself here in the beginning. The story of existence is a self-portrait. And here for Inkstone-Wander, for Shih T'ao and for us, the self-portrait looks like this: ridgeline layered beyond ridgeline, paper-pale sky, bare winter-charred branch-tangles, sky-infused sea-mist, mist hiding broken city walls, abandoned houses and orchards and gardens.

Publisher's note: Color plates referenced in this book appear beginning on page 131.

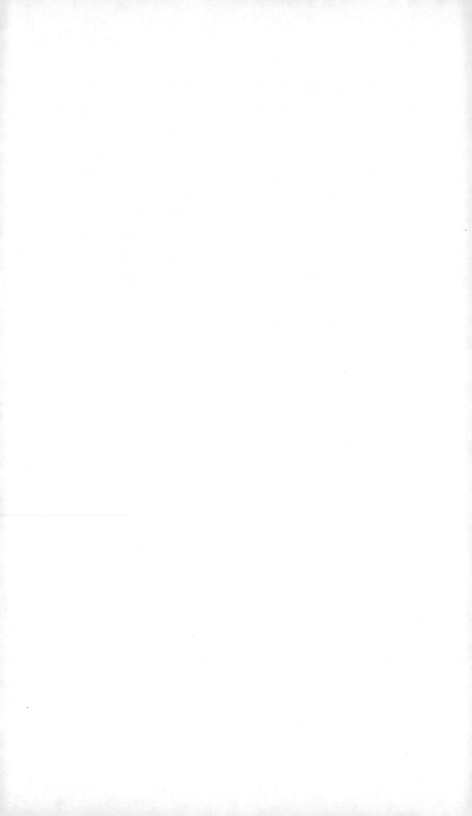

2

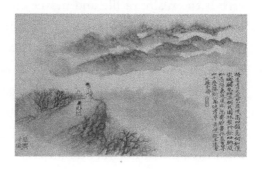

IF WE STAY AND SHARE a little longer this distillation of Shih T'ao's lifelong landscape practice, if we keep gazing into the nature of things here in the beginning, mind still emptied of all assumptions, yet another remarkable and unexpected fact soon reveals itself. This miracle of existence does not end with its boundless presence. Things move. They change. The existence-tissue is alive somehow—magically, mysteriously, inexplicably alive! It is whole, but not complete, never complete. It rustles. It moves. And this is true not

just of the verbal actions in which this mysterious aliveness is most plainly visible in the world; it is also true of the things themselves. Our language contains rigid distinctions between noun and verb. Things are noun, static entities, an assumption that drains them of life because verb is the realm of life and movement. And because the structure of language is the structure of thought, we choicelessly experience the world this way. But in fact, everything is alive, in process, verb—and that is how the Chinese conceptual framework sees it. Indeed, that view is embodied in the language itself, where all words can function as any part of speech. That is, there is no rigid distinction between noun and verb, so things are not linguistically deprived of their "verbness," their life. In addition, while words in our alphabetic language have an arbitrary and distant relationship to things, which gives things the sense of static and lifeless abstractions, the pictographic nature of Chinese means that words share the nature of things as living phenomena. And so in Chinese, at the most fundamental conceptual level of linguistic structure, the existence-tissue is wholly alive— magically, mysteriously, inexplicably alive!

This suggests a very different concept of time. We in the modern West inhabit time as a metaphysical dimension, a river of future flowing through present and into the past. This grand metaphysical assumption about the world structures our immediate experience, but it is purely imaginal, and it creates a strange schism between us and the vast tissue of transformation that is reality. As inhabitants

of this linear time, we are located outside of existence. But there is no trace of such a dimension in empirical reality. Here in the beginning, all such ideas forgotten, we experience ourselves *inside* existence, and "time" is nothing other than the movement of change itself, an ongoing generative moment in which every thing (noun) is alive (verb) and pregnant with transformation.

In that perennial moment, thoughts and memories appear and wander and slip away. Sea-mist drifts, ridgelines writhing and swelling, then eventually thins away. Valleys appear. Days pass into nights. Snows come. Seasons turn. Lives begin and end. Dynasties rise up and fall into ruin, like the Ming that was pillaged when northern "barbarians" overran China: cities plundered, villages razed, everyone in a last surviving branch of the imperial family murdered except a lone child who is miraculously spirited away from the slaughter by a servant, who is raised in a Ch'an monastery and eventually becomes Shih T'ao, "Stone-Waves," the great painter who spends his life wandering and making himself invisible, changing names and hiding his identity as a member of the Ming imperial family. Eventually, Stone-Waves declares himself in his painting of resistance. In the person of Inkstone-Wander, he hikes up to this mysterious place we can only imagine because painting and poem leave so much unsaid, this beginning place where a mountaintop far from people coexists with a broken city and its shattered houses. He stands there gazing out, and it is existence open to itself through its own empty awareness here in the beginning, open to: A battered city-gate perhaps,

hanging open, scavenged for firewood. A broken city-wall overgrown with weeds and gnarled trees, roots clutching at fissures in the stone wall. Scraps of curtain trailed out of ragged house-windows. Pears and apricots, frost-blackened reds and yellows sunlit in abandoned orchards. And in deserted gardens, a scattered confusion of chrysanthemums in ragged bloom: crimson, yellow, orange.

Vast and deep, everything and everywhere: existence is alive somehow—magically, mysteriously, inexplicably alive. Nothing holds still. The existence-tissue is pregnant through and through, subjective and objective a single generative tissue, all dynamic energy in perpetual transformation. This is the most fundamental nature of existence; and as we will see, it appears everywhere in the arts of China. But nowhere does it appear so directly or dramatically as in the twisting and tumbling form of dragon. Feared and revered as the awesome force of change, of life itself, dragon is China's mythological embodiment of the ten thousand things tumbling through their traceless transformations. Small as a silkworm and vast as all heaven and earth, dragon descends into deep waters in autumn, where it hibernates until spring, when its reawakening manifests the return of life to earth. It rises and ascends into sky, where it billows into thunderclouds and falls as spring's life-bringing rains. Its claws flash as lightning in those thunderclouds, and its rippling scales glisten in the bark of rain-soaked pines.

Existence, the Cosmos, the dynamic interplay of heaven and earth: it's all dragon, all generative transfor-

mation driven by a restless hunger, and every aspect of our subjectivity shares this dragon nature. Dragon is that vast mysterious existence-tissue given just enough form that we can *feel* it, its dynamic life writhing through its trace-less transformations here in the beginning. The mountains in Stone-Waves' painting have the seething feel of this dragon, as do the mountains in Plate 9, which might be described as a dragon about to lift off and soar away on a vast wind. But there are in the painting tradition many magisterial images of the dragon itself, as in the spectac-ular *Nine Dragons* by Ch'en Jung, where dragon's protean body writhes in and out of view among rock and water, cloud and mist:

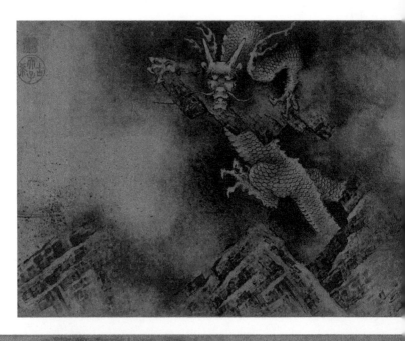

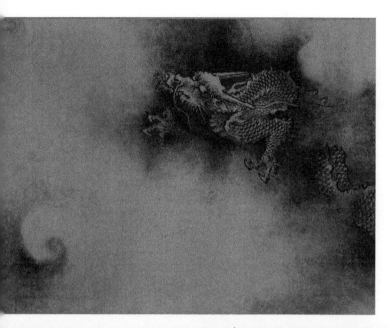

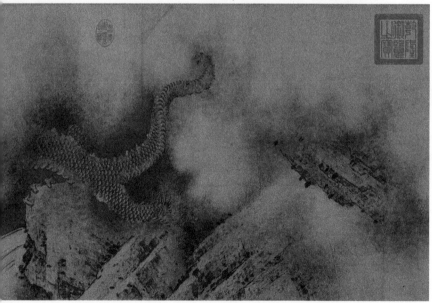

Ch'en Jung (13th century): *Nine Dragons* (1244). Detail.

Museum of Fine Arts, Boston

3

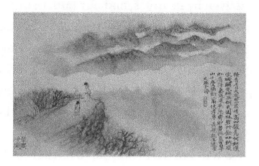

THE EXISTENCE-TISSUE is whole, but it is not complete, never complete. Sea-mist drifting, ridgelines writhing and swelling, dynasties rising and falling: dragon-form existence rustles, opening through awareness. It keeps moving, always moving. It's never satisfied. And there's more. Who could have imagined here in the beginning, all assumptions and ideas about things forgotten, here before all those assumptions ever existed—who could have imagined anything so unlikely and impossible? But it's true: this existence-tissue *wants* to

recognize itself, *wants* to celebrate and explain itself. It may seem recklessly anthropomorphic to speak of existence having *intentions* like this. But the concept of anthropomorphism presumes human consciousness is fundamentally different from everything else. The Cosmos is driven by its urges, and our human urges partake of those deeper movements, are particular instances of them, continuations of them. And what else could the restlessness of existence, its life, its constant motion of fact feeding on fact—what else could it be called but *hunger* or *want*?

Although this sounds suspect in the Western tradition, it is the cultural assumption in ancient China. As we will see over the course of this book, this assumption suffuses Stone-Waves' painting, and it appears explicitly as 意 (thought/intent) in the second line of the painting's poem:

搔	首	青	天	近	紫	虛
scratch	head	green-azure	sky/heaven	near	purple	emptiness

凌	高	四	顧	意	何	如
icy	height	four	views	thought/intent	what	like

意 might be translated provisionally as "thoughts" or "intentions," but here it is unclear where to locate these thoughts because the sentences lack subjects, which is normal in classical Chinese poetry. On the one hand, the

lines seem to be describing Inkstone-Wander's mental state as he scratches his head in wonder over the vast and empty heavens, feeling in an indescribable way the four limitless distances stretching out from the heights where he is standing. But the second line's grammar suggests *thoughts* could just as easily refer to the icy heights, or perhaps to the four vistas surrounding those cold mountaintop heights.

In fact, it is both of these possibilities simultaneously, for 意 is a philosophical term that refers to the "intentionality/intelligence/desire" that shapes the ongoing cosmological process of change and transformation. This is not intelligence in the sense of a divine presence. Instead, it is the inherent ordering capacity infusing the existence-tissue, and so it exists not in any divine or teleological way, but in an entirely empirical way, much as modern science describes with its fundamental principles and laws; though the rhetoric of science renders that "intelligence" lifeless, when it might just as easily and consistently be conceived as elementally alive. 意 is a capacity shared by human thought and emotion as well as wild landscape and indeed the entire Cosmos, and so it reveals the Chinese assumption that the human and nonhuman form a single tissue that "thinks" and "wants."

Indeed, the term meaning "culture," especially "literary culture," is 文 (*wen*), which originally referred to a design appearing on a surface (veins in rock, ripples on water), and 意 was the underlying force creating those patterns. 文 applies in its largest sense to the patterns of

the Cosmos, created by 意. Those patterns include such things as the patterns of stars, seasons, life and death, the diverse array of the ten thousand things, and finally, as another of those "natural" patterns, civilization: philosophy, writing, calligraphy, painting, etc.

Existence, when there might just as well be none: the sheer presence of materiality, vast and deep, everything and everywhere. Existence rustles. It wonders. It wants to recognize itself, wants orientation. It must, for it evolved animals like us that feel compelled to do such things. Recognition, orientation: how could it begin? A cairn, perhaps. Stones gathered, the largest few settled on flat earth, and the rest built up from there: slowly, one stone at a time, keeping things whole. A cairn is mute and elemental as empty awareness. It orients. It recognizes, and means in a sense everything around it, for where does it end? Its extent includes all of that elsewhere. It recognizes, but says nothing. Nothing about the landscape it orients around itself: distances of rivers and mountains. It orients and recognizes, and yet remains empty in a strange way, for it is about everything other than itself. It seems perfect, seems complete and still and whole celebrating the existence-tissue here in the beginning.

It's the simplest place in the world, this beginning, for the complications of memory and identity, thought and story and myth are perfectly absent. And it makes sense that the earliest art forms would be close to this beginning place, the existence-tissue just learning how to recognize itself, how to celebrate itself. A cairn, perhaps.

Or petroglyphs scattered through the planet's landscape, images chiseled across the burnt-ochre patina of boulders and cliffwalls: wanders and wave-forms, faces with eyes that light up at dusk on winter solstice, bear prints and fish and bighorn sheep, spirals and snakes, people and stars. Fabricated in the midst of earth's vast sun-drenched landscape out of the landscape's simplest elements, stone chiseling form into stone, they feel like art executed here at the very beginning. They feel like existence rustling, decorating itself with lightning and egret and sun, with wavelength festoon, wander-deep confetti, eye-lit celebration:

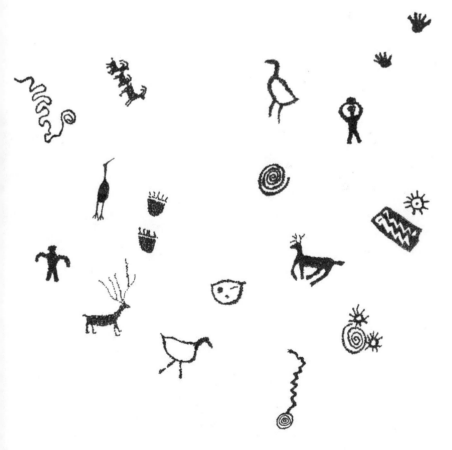

4

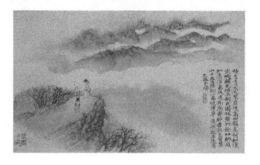

THE EXISTENCE-TISSUE is made of hunger. It rustles. It is alive, forever moving and changing. It wants to recognize itself, wants to celebrate and explain itself, to understand the bottomless depths contained in the surfaces of appearance. And in its hunger, it evolved language and thought. In the modern West, linguistic thought is experienced in a mimetic sense, as a stable and changeless medium by which a transcendental soul represents objective reality. This sense of language assumes language did not evolve out of natural process, but

that language is instead a kind of transcendental realm that somehow came into existence independently of natural process. In ancient Greece this was associated with the advent of writing, which was just beginning to reshape consciousness, creating a seemingly changeless interior realm of the soul. In the Judeo-Christian tradition, it was part and parcel with a god-created soul: Adam was created by God as a soul already endowed with language, presumably the language of God, since they spoke from the beginning and of course God created the universe by speaking commands, and so language was a transcendental medium that predates the appearance of humans as physical beings on earth. That god may be gone now; but when language functions in that mimetic sense, it still embodies an absolute separation between mind (soul) and reality, and that separation defines the most fundamental level of experience.

The history of language in China reveals that language was not experienced as a mimetic separation by the ancients, by Stone-Waves or Inkstone-Wander gazing out across ridgelines in the painting. They recognized language as an organic system evolved by the existence-tissue, as the existence-tissue describing and explaining itself. In the cultural myth, language begins in China with the hexagrams of the *I Ching*, such as the first two, *Heaven* and *Earth*:

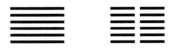

These hexagrams embody the two fundamental elements of the Cosmos: *yin* and *yang*, female and male, whose dynamic interaction produces the cosmological process of change. The solid lines are *yang*, the broken lines *yin*, and the *I Ching*'s sixty-four hexagrams include every possible combination of *yin* and *yang*. A language is at bottom a description of reality, and the hexagrams describe the basic configurations of change, so they are a proto-language, the first stage in existence's urge to recognize and describe itself. Indeed, in the cultural myth, they were created by the first man: Root-Breath, who emerged from Bright-Prosperity Mountain and was in fact half dragon, half human. That is, they grew out of earth and natural process.

The hexagrams did not attempt to describe the particulars of reality, but to embody the deeper forces and processes of reality. This engendered a similar assumption about the Chinese language which, according to cultural legend, appeared after the hexagrams. Rather than referring mimetically to things in the world (an assumption that sees reality primarily as noun, as permanence), classical Chinese words embody the configurations of change (thereby seeing reality primarily as verb, as transformation). A word did not so much refer to a thing as share that thing's embryonic nature. That is, in the ongoing transformation of things, words emerge in the same way that the ten thousand things emerge, and from the same origins. And so, rather than alphabetic marks that are distant and arbitrary signs referring to reality from outside, ancient China's artist-intellectuals ideally

experienced words without the dualistic divide between empirical reality and language/consciousness as a kind of transcendental realm.

They sometimes felt that separation, though never as a fundamental metaphysical breech as in the West, and overcoming it is what spiritual practice was largely about. In their spiritual and artistic use of written language, in poetry and calligraphy, they experienced language as a return to origins, as the existence-tissue speaking through us, describing and understanding itself through us, decorating itself with meaning. Here we encounter the tantalizing fact that to translate a Chinese poem into English is to fundamentally misrepresent it, because the mimetic function of English, with its distancing, is exactly what a Chinese poem is meant to undo.

The Chinese language itself encourages this experience of origins, perhaps most obviously in its pictographic nature; wherein words are in fact images of things, and so share with things their origins and essential natures. In this, the language keeps alive its origins in primal image-making, like petroglyphs. We tend to look at primal art like petroglyphs and cave art through our own cultural lens, with its dualistic assumptions in which we are transcendental souls radically separate from the world around us. We assume that in chiseling animal figures into rock, artists were rendering objects outside of themselves in the world, much like an artist today would render something like an antelope. But primitive artists were largely free of those assumptions, because they were operating here in the be-

ginning, where consciousness and existence are still a single tissue. When they etched an antelope in rock, there were no boundaries between self and antelope, self and rock. Instead, they were acting at the origin-place where antelope and image share their source, where they were bringing that antelope into existence here in the beginning, creating the way the Cosmos creates. That could only be described as a spiritual experience, a spiritual practice: the existence-tissue creating itself, decorating itself, caressing itself, celebrating itself. And again, as a matter of actual immediate experience, that is how words still work for us in our everyday lives.

This body of nondualistic assumptions remained alive in the Chinese language with its ideograms[*] that in their earlier forms often look remarkably like petroglyphs (pp. 22 ff.). In this, ideograms maintained their nature as visual art where an imaged thing is experienced as both noun and verb simultaneously, as alive. And at the same time, it is experienced non-mimetically. These distinctive characteristics of the language are emphasized and exaggerated in poetry, and they function as the essence of poetry as a spiritual practice. In this sense, Chinese poetry can be thought of as returning the experience of language and its ideograms to their sources, which feels very close to petroglyphs that exist prior to the separation of consciousness and landscape / Cosmos.

[*] This term is used in its common sense, where it simply refers to Chinese written words while emphasizing their distinctive graphic form.

Equally profound is the way classical Chinese leaves out subjects and most other grammatical material, a characteristic that poetry exploits dramatically. In the poem inscribed on Stone-Waves' painting, for instance, that grammatical minimalism renders Inkstone-Wander on the mountaintop not as a transcendental soul undergoing experiences, as a Western poem would, but as the existence-tissue experiencing itself:

搔	首	青	天	近	紫	虛
scratch	head	green-azure	sky/heaven	near	purple	empti-ness

凌	高	四	顧	意	何	如
icy	height	four	views	thought/intent	what	like

In reading such a text, we conjure a subject from empty grammatical space, though it remains much more a nebulous presence than the clear definition that a pronoun produces. Here, the absent subject resides in the empty space preceding *scratch*. We read it first as *I*, because the convention for lyric poems like this is that they are about the poet's immediate experience. But there are other possibilities for the missing pronoun: *you* or *he/she*, or the more universal *we* or *one*. The poetic language refuses to choose between those possibilities, and so describes the situation as a universalized human experience, or as the experience of human consciousness in general.

And because we initially read the line with a first person *I*, that ambiguity enlarges self-identity into this general sense of shared consciousness that includes Stone-Waves and us, which reinforces the sense that we are meant to identify with the gazer in the painting.

So, reading *I* in this enlarged sense of consciousness, the first line is read provisionally: *[I] scratch my head in wonder at green-azure heaven so close to purple emptiness.* Here, consciousness appears as an absent presence, an empty grammatical space that only implies the presence of consciousness. But in poems like this with seven ideograms per line, there is always a grammatical pause after the fourth ideogram, and that presents a second possible reading: *Scratching my head in wonder at green-azure heaven, [I] am close to purple emptiness.* Because the line offers no grounds for choosing between these two readings, it begins to suggest a sense of consciousness as an absent presence distributed throughout the line, more and more indistinguishable from the green-azure heaven and purple emptiness we see in the painting. And remarkably, this sense is encouraged by the line's grammatical minimalism, for the line could be read without pronouns, thereby conjuring a complete integration of consciousness and landscape: *Green-azure heaven scratches its head in wonder this close to purple emptiness.*

This reading is suggested by the philosophical resonance of 天. Although its primary meaning here is simply "sky," 天 also means "heaven," which is a central philosophical

concept with a long history. For a time in early China, 天 was an impersonal deity that created and controlled all aspects of the Cosmos, but this concept was secularized and came to mean essentially "natural process," thereby investing existence with the aura of the sacred. That concept informs the reading of this line, for the *I* has become "heaven" scratching its head. And so, Inkstone-Wander is returned to his place as an integral part of heaven, or the existence-tissue.

The poem's fifth line produces a similar effect, for Inkstone-Wander again appears as an absent presence in the grammatical pause after the fourth ideogram:

吐	納	成	虹	看	海	氣
exhale	inhale	city	rainbow	gaze	sea	*ch'i*

This suggests the most straightforward reading of the line: *As a rainbow breathes in and out of view over the city, [I] gaze into sea-mist.* But in the most grammatically direct reading, it's the rainbow that is looking. This ambiguity creates a weave of consciousness and landscape, encouraged by the description of the rainbow as inhaling and exhaling, and the fact that early legend considered the rainbow to be a rain-dragon: *A rainbow breathing in and out of view over the city, [I] gaze into sea-mist*, a reading that identifies the *I* with dragon, embodiment of cosmological change and transformation.

Even though much encourages us to fill in the poem's empty grammatical space with personal pronouns, the

poem does not definitively even specify this as a *human* experience. With its grammatical space emptied of restrictive pronouns, the Chinese does not separate a center of identity out from the tissue of existence, and it certainly does not create a transcendental soul as English does. Instead, all of these empty grammatical spaces might more accurately be filled in with something like *existence-tissue (in human form)*. The 意 (*intentionality/intelligence/desire*) in line 2 reinforces this reading, for as we have seen, the "thoughts" could as well be the landscape's "thoughts" as Inkstone-Wander's or Stone-Waves'. And all along, because of the first-person presumption, the poem as spiritual practice returns Inkstone-Wander/us to his/our place as an integral part of the existence-tissue. This establishes the texture of the entire poem, defining it not as the experience of a transcendental soul as we would assume in the West, but of consciousness indistinguishable from the existence-tissue here in the beginning:

搔	首	青	天	近	紫	虛
scratch	head	green-azure	sky/heaven	near	purple	empti-ness

凌	高	四	顧	意	何	如
icy	height	four	views	thought/intent	what	like

漠	家	城	闕	朱	垣	在
aban-doned	house	city-wall	gate	red	wall	at/remain

何	氏	園	林	碧	艸	餘
what	family	garden	forest	emerald	grass	remnant
吐	納	成	虹	看	海	氣
exhale	inhale	city	rainbow	gaze	sea	*ch'i*
迢	逆	無	鴈	寄	鄉	書
distant	distant	no	geese	send	home-village	letter
拖	藍	曳	翠	山	千	疊
drag	indigo	trail-out	kingfisher-green	mountain	thousand	folds
隔	斷	江	南	使	者	車
separated	cut-off	river	south	employed	(those who are)	carriage

5

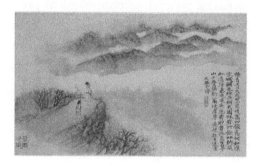

ALTHOUGH CLASSICAL Chinese does not entail a metaphysical rupture between a transcendental soul and material existence the way Western languages do, there was nonetheless a rupture, even in a simple word naming the existence-tissue. Such a word would come early in the existence-tissue's desire to understand itself, would it not, an utterance driven by the wonder that appears in the poem's first couplet, perhaps, a name for the whole of existence, for the expansive presence of existence and empty awareness as

part of that existence. For Stone-Waves that first-word is *Tao* (道), the central concept from Lao Tzu's *Tao Te Ching,* which is the seminal work in Chinese spiritual philosophy, its story of existence. Lao Tzu's *Tao* means *Way,* and it describes the existence-tissue as verb rather than static noun, a generative cosmological process, an ontological path*Way* by which things come into existence, evolve through their lives, and then go out of existence, only to be transformed and reemerge in a new form.

One of Lao Tzu's favorite images for Tao is water, because however much its form changes, water remains itself; and in its constant movement, it "enriches the ten thousand things, and yet never strives." He also uses this image to show how mind is wholly a part of Tao, saying "mind's nobility is empty depths." Here, the ideogram for those "empty depths" is 淵, which Lao Tzu no doubt relished because in his era the ideogram was clearly an image of flowing water (streamwater with its ripples) within empty space: (𣶏). Hence, mind as mirrored emptiness in liquid motion, which appears dark and enigmatic indeed in the ideogram's early oracle-bone form: 𣶏.

And there is in Lao Tzu's story of existence another seminal name for the whole of it: *tzu-jan* (自然). Literally meaning "self-so" or "the of-itself," *tzu-jan* was meant to emphasize the particularity and self-sufficiency, the *thusness,* of each of the ten thousand things that make up the generative process of Tao. And so, it is best translated as "occurrence appearing of itself," which opens a first description of the Cosmos here in the beginning where

the existence-tissue is whole: "from nowhere else, occurrence."

The expanse of awareness and the expanse of existence: here in the beginning, it is whole, a single tissue. When occurrence rustles, there is nowhere else. Sea-mist swells through mountain valleys. A rainbow appears over a broken city. Existence wonders about itself here. It breathes. It invents us, these centers of identity, and through us, it whispers names for itself: *existence-tissue* and *heaven, Tao* and *tzu-jan*. It whispers explanation: *from nowhere else, occurrence.* When we use language like this, we are thinking *about* something elsewhere, taking existence as a subject of investigation, of knowing. Even in a first name or explanation it has begun. Even these first words whisper our separation from the Cosmos. Even as they argue against that separation, describing awareness and existence as a single tissue, they whisper a center of identity distinct from the world around us. They whisper an elsewhere. And that easily, in a few simple words, the existence-tissue seems no longer whole.

How can it be that a first name or explanation changes everything? *From nowhere else, occurrence:* that explanation feels like a moment we first glimpse the nature of existence, and yet at that very moment, everything changes. Suddenly we are centers of identity, and the existence-tissue is separated from itself. You can feel it already: existence is out there, and we are here inside this cocoon of thought and identity looking out and naming it, describing it, explaining it. But however precisely we

name this tissue of existence, however perfectly we explain it with philosophical insight or scientific description and theory and information, however powerfully we evoke it with poems and stories and grand mythologies— those explanations are always about an elsewhere, a wholly self-contained ontological ground that exists in and of itself, untouched by our words, a vast and elemental mystery that eludes us completely. Existence decorates itself with identity and meaning, just as it decorates itself with mountain ridgelines and sea-mist, cities and rainbows. And yet (how can it be?), as soon as existence begins to know itself, it is lost to itself. Existence rustles. It wants to know itself; and in the end, it cannot. It can only elude itself.

A cairn seems perfect: saying nothing, explaining nothing. A cairn simply orients. It is the existence-tissue complete and still and whole recognizing itself, orienting itself. And petroglyphs seem perfect too: the existence-tissue decorating itself, celebrating itself. Cairn and petroglyph: they seem like enough. And yet, existence rustles. It wants more. It wants to understand itself. It wants to understand its bottomless depths. But understanding, in the form of language and thought, creates an interior realm; and inhabiting that realm through their day-to-day lives as bureaucrats and artist-intellectuals, lives remarkably similar in their basic outlines to ours today, the Chinese ancients felt a separation between themselves and the existence-tissue. That rupture was the texture of their lives, and it is also part of the story of existence.

But there is a profound difference between ancient China and the modern West, for Chinese thought and language do not entail a metaphysical rupture between a transcendental soul and material existence the way Western thought and language do. The West's metaphysical rupture appears absolute and integral to the structure of reality, but sage wisdom in ancient China considered the rupture a loss of wholeness. It was the existence-tissue lost to itself, which would have felt to Stone-Waves like a boundless dimension of himself was lost. That is why he created the world of this painting, with its figure on a mountaintop gazing wordlessly out at those ridgelines. Self-cultivation in China meant healing that rupture and returning to that part of ourselves we have lost: the existence-tissue, vast and deep, everything and everywhere. It meant dwelling here in the beginning where the existence-tissue is whole.

6

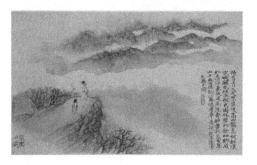

ANCIENT CHINESE artist-intellectuals experienced themselves in everyday life as centers of identity. Typically bureaucrats working in the government, they analyzed situations and made rational decisions on which the well-being of many people depended. They were often very unique and quirky and forceful personalities. But they never experienced themselves as transcendental souls. And beginning with the philosophical system preserved in Lao Tzu's *Tao Te Ching* from the sixth century B.C.E., China's ancient sages found ways to weave

the center of identity back into all of this wholeness, to know themselves outside of language and explanation and identity here in the beginning, where existence itself is no longer separate from us, where it no longer eludes us, no longer eludes itself. This impulse begins with the first lines of Lao Tzu's *Tao Te Ching*, the earliest utterance in the Taoist philosophical tradition:

A Tao called Tao isn't the perennial Tao.
A name that names isn't the perennial name.

The first line is famously ambiguous because *Tao* also means "to say," so the line might be translated "A Tao that can be described/explained is not the perennial Tao." For Lao Tzu, sage wisdom involved seeing existence accurately and wordlessly in all its magisterial presence, and dwelling as an integral part of that presence. Eventually, Lao Tzu's insights were honed into a formalized spiritual practice in Ch'an (Zen) Buddhism. After its appearance around 400 C.E., virtually all artist-intellectuals in ancient China practiced Ch'an as a form of Taoist thought refined and reconfigured by Buddhist practice. Most artist-intellectuals practiced in monasteries as visitors rather than full-time monks, but Stone-Waves was a Ch'an monk for many years. In fact, he rose to become a Ch'an teacher who thought of himself as teaching not only in the conventional sense, but also through his paintings; and he gathered his influential collection of writings on painting under the title *Enlightenment Teachings* (語錄), which is

a conventional title for collections of teachings by Ch'an masters.

Here in the beginning, there is no commerce or profit, no politics or ethnicity or war, no upper class or lower class, no stories or myths or ideologies, no explanation and no self. It is a refuge where there are no words, a refuge vast and deep, everything and everywhere. Cairn and petroglyph designate this place, for they say nothing. They orient and celebrate. They keep things whole here in the beginning. But for us to enter that refuge requires the effort of a spiritual practice, and for the ancient artist-intellectuals, that practice was primarily Ch'an.

Records recounting the lives and teachings of Ch'an masters are replete with enigmatic sayings and wild antics intended to upend reason and tease mind past the restraints of a center of identity with its logical thought, thereby opening consciousness to the possibility of dwelling in the ontological wholeness of the existence-tissue here in the beginning, the wholeness that Lao Tzu called the "perennial Way." Koans are especially revealing scraps of poem and story drawn from those records, puzzles assigned to help students move beyond the limitations of reason and logical thought. Solutions to such koans always involve responding with a spontaneous immediacy that lies outside logical analysis; and in koan training, the teacher may push the student toward that goal with enigmatic utterances and outbursts and antics. The correct answer to a koan is whatever emerges spontaneously from that silent emptiness where the logical

construction of thoughts has not yet begun, and such answers are only possible when a student has come to dwell here in the wholeness of the beginning. And so, they are a way of teaching outside of words and ideas, a way of directly transmitting this experience of empty awareness here in the beginning.

One of the most illustrious koan collections is known by a title which is itself a kind of distilled koan: the *No-Gate Gateway* (*Wu-men Kuan*: 1228 C.E.), and it includes puzzles like these:

Origin-Mountain's Bamboo Staff

Master Origin-Mountain raised his bamboo staff before the assembly, and said: "Alright you monks. If you say this is a bamboo staff, you violate what it is. If you don't say it's a bamboo staff, you deny what it is. So, tell me: what is it?"

Million-Million Holds Up One Finger

Whenever a question was posed, Master Million-Million simply raised a finger. Now, Million-Million had a houseboy, and one day a visitor asked this boy: "What is the dharma-essence your master teaches?"

The boy held up his finger, like the master.

Hearing of this, Million-Million chopped the houseboy's finger off with a cleaver. Howling in agony, the boy turned and fled. Just then, Million-Million

called to him. When the boy looked back, Million-Million held up his one finger. Suddenly, the boy was enlightened!

When Million-Million was about to follow the vanishing way of things, he said to the assembly: "I received this one-finger Ch'an from Heaven-Dragon. I used it for an entire lifetime, and never exhausted it."

With those words, he passed into extinction.

Koan study reinforces meditation, which is the heart of Ch'an practice, its primary means of moving past that illusory separation between consciousness and Cosmos. Again distilling a lifetime of practice into a few moments, into the essence, meditation would look something like this for Stone-Waves. He begins by sitting quietly and watching thoughts come and go in a field of silent emptiness. From this attention to thought's movement comes meditation's first revelation: that we are, as a matter of observable fact, separate from our thoughts and memories. That is, we are not the center of identity we assume ourselves to be in our day-to-day lives, that center of identity defining us as fundamentally outside the existence-tissue. Instead, we are the empty awareness (known in Ch'an terminology as "empty mind") that watches identity rehearsing itself in thoughts and memories relentlessly coming and going. Eventually the stream of thought falls silent, and Stone-Waves simply inhabits empty mind, free of that center of identity. That is, he inhabits the most fundamental nature

of consciousness, the dark and empty awareness we share with Inkstone-Wander on the mountaintop, before opening our eyes to the existence-tissue here in the beginning.

When he opens his eyes here in the beginning and gazes out into mountains and mist, Inkstone-Wander opens the perceptual act of empty mind attending to the ten thousand things with mirror-like clarity. This is the heart of landscape as a spiritual practice, why Inkstone-Wander and Stone-Waves and countless other artist-intellectuals spent so much time in mountain landscapes. This practice involves two aspects. First is the simple fact that only with empty mind can one attend to the ten thousand things wholly, for thought inevitably distracts attention from the perceptual moment, thereby separating us from our bodily experience in the world. The second aspect is perhaps less obvious, though it is closely related to the first. Thought is always *about* something outside itself, creating the illusion that we are somehow fundamentally separate from the Cosmos; and that illusion is reinforced by the apparent structure of perception, because the center of identity makes perception seem always to be *of* something else. But here in the beginning prior to the center of identity, whether on the mountaintop or deep in meditation, the opening of consciousness itself is a bottomless mirror allowing no distinction between inside and outside. Identity becomes whatever sight fills eye and mind, becomes the existence-tissue vast and deep, everything and everywhere. And we share that identity with Stone-Waves when we gaze mirror-deep into his painting.

Landscape practice as mirror-deep perception adds another dimension to the magic of Inkstone-Wander's poem. Its grammatical identification of consciousness and landscape reflects this aspect of landscape practice, the way mirror-deep perception integrates consciousness and landscape as a matter of immediate experience, for the eye opens landscape through us, returning us to the undifferentiated existence-tissue here in the beginning. It is whole: empty awareness and this expansive presence of existence. It is a single tissue. And to dwell here in the beginning, before all of the words and explanations, empty mind mirroring the ten thousand things with perfect clarity—that is complete and whole. It is to know existence open in its fullest dimensions, to *feel* all of that depth.

Emotion is limited by Judeo-Christian assumptions about the transcendental soul that would seem to rule out feeling landscape. But the word for "mind" in classical Chinese is also the word for "heart": 心 (a stylized version of the earlier 心, which is an image of the heart muscle, with its chambers at the locus of veins and arteries). There is no ingrained distinction between the two. And *mind* refers not to the abstract analytical faculty that we normally associate with that word. Instead, it refers to the empty awareness that Stone-Waves encountered in meditation, that we encountered before opening our eyes here in the beginning. So it is not just a spiritual experience, this perception clarified by meditation until it is empty *mind* mirroring the ten thousand things, mirroring the landscape of

Stone-Waves' painting; it is also an emotional experience, an experience of the *heart*:

Frost-blackened pears and apricots. Disheveled city walls, gate. Veils of sea-mist, empty purples. Crimson walls. Tumbledown houses. Mountains, a thousand ridge-lines flaunting indigo-blues and kingfisher-greens. Frost-charred orchard tangles, branches lit for a moment, then charcoal-dark again. A rainbow over the ruins of a once populous city. Sheer distances spreading away into the four directions.

7

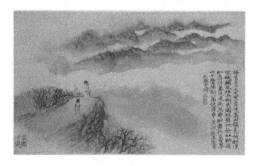

VAST AND DEEP, everything and everywhere: the miracle of existence does not end with its boundless presence; and it does not end with the fact that it is alive, a tissue of perpetual transformation. There's more! If we wait long enough here in the beginning, sharing Inkstone-Wander's gaze into the existence-tissue, awareness empty of all assumptions, we encounter yet another marvel, breathtaking and heartbreaking too: things disappear! Existence doesn't simply subsist in its sheer materiality, doesn't simply move

through its transformations. It disappears into thin air: people crowding cities vanish, leaving abandoned houses; mist and cloud vanish; even mountain ridgelines eventually vanish. Everything we see before us disappears! And as it is part of the same tissue, mind works the same way. Thoughts and emotions, memories and perceptions: they are all constantly disappearing.

This existence-tissue here in the beginning, its ten thousand things filling our gaze: they are forever vanishing. But it is stranger still, for even while things disappear, other things appear! Things appear out of nowhere! The existence-tissue is truly alive, and it is pregnant through and through! Children are born; cities and civilizations arise; mist and cloud materializes; mountains writhe up into sky. On a bare and dead winter branch, blossoms and leaves appear, then pears form and slowly grow larger and larger, apricots too, the sun's warmth gradually infusing their skin with color. The dragon is not just an image of transformation, but also an image of appearance and disappearance. It is the embodiment of all creation and all destruction, its forms appearing and disappearing through one another as cycles of birth and death unfurl their generations.

Existence is whole, but it is not complete, never complete. Occurrence begins and ends here in the beginning. Seasons come and go. Civilizations rise and fall. Existence rustles. It wonders. It wants to explain its nature as appearance and disappearance. It wonders. And the explanation it conjured in ancient China was a first distinction

in its undifferentiated wholeness: *Absence* (無) and *Presence* (有), the two fundamental principles of the Cosmos that appear in the first poem of Lao Tzu's *Tao Te Ching*:

> In perennial Absence you see mystery,
> and in perennial Presence you see appearance.

Presence is simply the empirical universe: the ten thousand things in constant transformation, existence vast and deep, everything and everywhere. And Absence is the generative void from which this ever-changing realm of Presence perpetually emerges. The dynamic interaction of Absence and Presence is what Lao Tzu called *Tao*, and it explains how things appear and disappear: they appear out of Absence and disappear back into Absence. This process is manifest in the annual cycle of seasons: the pregnant emptiness of Absence in winter, Presence burgeoning forth in spring, the fullness of its flourishing in summer, and its dying back into Absence in autumn, which leads back into winter, season of Stone-Waves' painting.

Lao Tzu's generative cosmology and its operations appear in the first two lines of Inkstone-Wander's poem, deepening their sense dramatically:

搔	首	青	天	近	紫	虛
scratch	head	green-azure	sky/heaven	near	purple	emptiness

凌	高	四	顧	意	何	如
icy	height	four	views	thought/intent	what	like

Here, Absence appears in the form of 虛, for *emptiness* was a philosophical synonym for *Absence*, and 意 is the "intentionality/intelligence/desire" infusing that emptiness and shaping its burgeoning forth into the ten thousand forms of Presence. The appearance of these ideas here is hardly surprising, because Lao Tzu's cosmology remained central throughout the cultural tradition. Inevitably, as at the end of the second line of this couplet, Lao Tzu's Cosmos inspires awe, for each of the ten thousand things, consciousness among them, seems to be miraculously burgeoning forth from a kind of emptiness at its own heart; while at the same time, it is always a burgeoning forth from an emptiness at the very heart of the Cosmos itself. And to be alive is to be always there on the wondrous crest of that burgeoning forth.

Here again we encounter that more primal and accurate feeling for time. Not linear, the familiar metaphysical river flowing past, and not even cyclical (as we probably wrongly describe time in primal cultures), it might be called *return-time*, for it is an all-encompassing generative present, a constant burgeoning forth in which the ten thousand things (Presence) emerge from Absence and return to that same source. This goes back to the earliest levels of Chinese culture, where the *I Ching* says: "In return itself, you can see the very heart-mind of all heaven and earth." And it goes even further back, to the very origins of language, for classical Chinese did not have verb tenses that describe the linear time familiar to us in the West. Rather than embodying a metaphysics

of time, rather than tenses reifying a metaphysical river of past, present, and future, the uninflected verbs of classical Chinese simply register action, that steady burgeoning forth of occurrence appearing of itself (*tzu-jan*). Although the Chinese had histories and calendars and clocks, such ideas of measurable time were superimposed on this more fundamental and primal experience of time, and as we will see, one purpose of art was to return them to that primal experience of time.

Lao Tzu often employs female terminology to describe the elemental contours of Absence, the dark and mysterious source of all appearance: "mother of all beneath heaven," "nurturing mother," "dark female-enigma." This female cosmology feels very primal, and probably dates from the earliest levels of human culture, levels when the existence-tissue first began decorating itself with celebration and meaning. That makes sense anthropologically, and the *Tao Te Ching* is in fact a compilation of wisdom texts from an oral tradition that may date back to those early cultural levels, levels that appear fairly universal among Paleolithic cultures. Indeed, that generative cosmology seems to appear in some of the earliest surviving examples of art in China: Neolithic basins and pots whose form began as Presence (clay) that was shaped to create an Absence (interior) which in turn was filled with Presence (water, grain, etc.); and whose designs show empty space seemingly generating dynamic flows of energy, designs in which you can *feel* the existence-tissue alive here in the beginning:

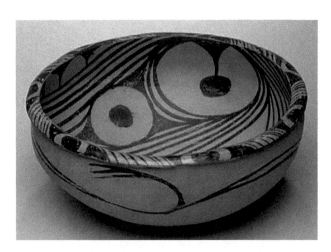

Neolithic basin (ca. 3200–2650 B.C.E.)

Metropolitan Museum of Art, New York

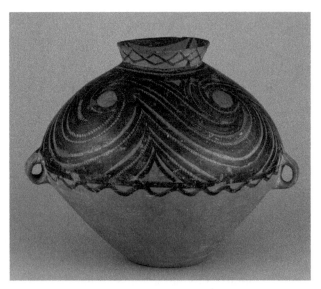

Neolithic jar (ca. 2650–2350 B.C.E.)

Metropolitan Museum of Art, New York

Classical Chinese civilization was remarkably evolved and subtle and complex, but it never lost its connection to the primal. For Stone-Waves and his fellow artist-intellectuals across the ages, this generative cosmology of Absence and Presence structures the most fundamental levels of human experience. And this kept them always close to the beginning. In Ch'an meditation, that cosmology is revealed as the very structure of consciousness, for meditation allows you to watch thought emerge from a generative emptiness, follow its dynamic evolution, and finally return back into that emptiness: Presence emerging from and returning to Absence in a process of constant transformation. That is, meditation returns us to the generative source of things, a fact already recognized at the earliest levels of Taoist thought, as in a tale from *Chuang Tzu* where Confucius asks Lao Tzu what happens when he sits still, and Lao Tzu replies: "I wander mind at the beginning of things." This is a return to the elemental mystery of creation; and at the same time, it reveals consciousness as an integral part of the cosmological tissue: thought, memory, identity, all moving with the same dynamic energy as the Cosmos itself. And once thought falls silent, that dwelling deepens; for in empty mind, that moment here in the beginning just before we open our eyes and look out at Stone-Waves' landscape, consciousness is wholly Absence.

In this mirror-deep empty mind, the ancients experienced perception as nothing less than Absence itself mirroring Presence. At this level, meditation is essentially

a formalized practice that returns us to this beginning place, this moment where we open our eyes and Absence itself gazes into Presence. It is a return to our original nature, for in that mirror-deep perception made possible by empty mind, consciousness is nothing other than the Cosmos looking out at itself, or more precisely: the source of the Cosmos gazing out at the Cosmos it has magically generated.

8

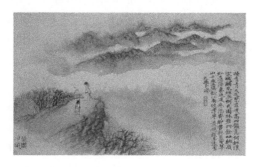

P OETRY, CALLIGRAPHY, PAINTING—at
their deepest level, the three arts that
come together in Stone-Waves' composition enact the
experience of dwelling here in the beginning, identity
woven wholly into the tissue of existence. In this they
were forms of spiritual practice, forms of cultivating an
empty mind, but an empty mind given the emotional
depth of a full heart. They usually involve some personal
dimension, as Inkstone-Wander's composition describes
himself isolated and far from home, alive in a landscape

of mountain distances and city ruins in the aftermath of a war that left the Ming Dynasty broken and China ruled by foreigners, an isolation Stone-Waves shared deeply. But whatever else is happening in these artistic practices, whatever human concerns they express, dwelling here in the beginning is the foundation, the experience of dwelling as an empty mind and a full heart. And it makes sense: existence doesn't just want to explain itself; it wants to feel itself too.

Poetry was sometimes referred to as "poetry-*Ch'an*." Although made of words, it is at its most profound level a spiritual practice opening consciousness to an immediate experience of the existence-tissue that precedes thought and language. Ancient artist-intellectuals saw in their pictographic language a world of living images, even if the pictographs were stylized and simplified, transformed and combined with phonetic material. This kept them close to the beginning always, allowed them to dwell here before all of the words and explanations and stories, empty mind mirroring the ten thousand things, for the language constructs meaning from the immediate experience of that mirroring. And poetry is the language's most distilled expression:

搔	首	青	天	近	紫	虛
scratch	head	green-azure	sky/heaven	near	purple	emptiness

Pictographic images are everywhere here in this first line from Inkstone-Wander's poem. 搔 (scratch) looked

like this in its earlier, more organic form: 爲, an ideogram constructed from a combination of a wrist and hand with five fingers on the left, and on the right an insect (勾) beneath another hand. 首 is a stylized simplification of early forms showing a head with eyes, mouth, ears, forehead and hair: 𦣻. 青, which is a range of blue-green colors found in nature, from forests to distant mountains and skies, includes a plant sprouting from the ground: 𤯓. 天 generates an image for "sky/heaven" by placing a line above the image for a person seen from the front (大, oracle-bone form: 大): hence, that which stretches out above humans. 近 includes a stylized image for a foot on the left (derived from 止, which is a schematic picture of a foot, showing: heel on the bottom left, toes to the right, leg above with an ankle indicated to one side), suggesting walking (and so, coming "near to"). The other element is the image for an axe formed of the tool itself and perhaps a curling chip of wood on the right: 斤 (a phonetic element, but which is also the very image of nearness and immediacy: the blade cleaving cleanly into wood). 紫 derives from: 𦂅, where its primary image on the bottom renders silk, showing a pair of cocoons with silk emerging in the form of three strands that would have been spun into thread and dyed colors like purple: 糸. Above this is the image for foot again, and to its right a side-view image of a person walking, which together form a phonetic element. Finally, the early form of 虛 is 虛, containing a pair of mountain peaks (𠃊) and, in the space above those peaks, a tiger: 虍, its image showing

a head at the top right, tail at bottom right, and left of the body curving between them, four legs. This ideogram can be traced back through more organic forms, such as 㿟, where the whole image has the fluid feel of a tiger in motion, to earlier incarnations rendering the thing in and of itself: 㿟. Hence: emptiness as "mountain tiger-sky," the emptiness of mountain skies that are also alive with the dynamic energy of a tiger.

In line after line, poetry constructs meaning like this—empty mind mirroring things in and of themselves. And in addition, distinct from the pictographic nature of the language, Chinese poets mostly think in images, in the things we encounter as the everyday world of immediate perceptual experience. Poems are full of landscape, like Inkstone-Wander's mountain ridgelines and sea-mist, abandoned orchards and city ruins. And so, the spiritual practice of Ch'an empty-mind mirroring is always present as a poem's most fundamental dimension, for it is in immediate day-to-day experience that one dwells here in the beginning: that primal gaze, a gaze of such clarity it is the gaze of existence looking out at itself.

Mirror-deep images and pictographs embody Lao Tzu's *tzu-jan*, "occurrence appearing of itself," a principle we can understand more deeply in terms of Absence and Presence. Emphasizing the particularity and thusness of individual things in and of themselves, *tzu-jan* is Lao Tzu's name for the ten thousand things emerging spontaneously from Absence, the generative source, each ac-

cording to its own nature, independent and self-sufficient, then eventually dying and returning to Absence, only to reappear transformed into other self-generating forms. And the full structure of this cosmology is replicated in the grammatical structure of the language. As we have seen, this grammar is minimal in the extreme, leaving a great deal of open space in the poem: all words can function as any part of speech, subjects and pronouns are often missing, verbs have no tense, function words (conjunctions, prepositions, articles, etc.) are rare, there is no punctuation, etc. This open space feels like an extension of the open space that surrounds the poem, and together they are a single tissue of emptiness: Absence, the source-tissue. And emerging from that Absence is text with its individual pictographic words: Presence in exactly the same way that the ten thousand things are Presence. In this, poetry participates in that more primal experience of time as an ongoing generative moment, which also defines the texture of the poem, for the wide-open grammar and absence of verb tenses creates a sense that the events of a poem occur in a kind of boundless present.

This textual cosmology was experienced both by the writer and reader of a poem. The writer experienced composition as words emerging from Absence, both the Absence of the blank page and the Absence of empty mind, much like thought seen emerging in meditation. And although it becomes second nature and routine, the structure of few words in a field of grammatical

emptiness means a reader is always coaxing meaning out of the open depths of Absence, always inhabiting that originary moment between Presence and Absence, meaning and meaninglessness. This is important: text and emptiness are not symbols or metaphors for the way Absence and Presence operate in the empirical realm. They operate in exactly the same way, and text was experienced as a living organism of image and meaning and sound. There is no fundamental distinction between language and reality, mental and empirical. They are both part of a single generative existence-tissue.

Here we see at a deeper level than before (pp. 25ff.) the fundamental difference between how language operates in the West and China. In the Western mimetic model, language is experienced as a transcendental realm of arbitrary (alphabetic) signs that refer to reality. This referential relationship fundamentally separates us from reality, distancing it as a kind of elsewhere, and its rigid category of nouns ossifies things into static and lifeless entities. By contrast, classical Chinese was understood as part of the existence-tissue's movements. In Chinese with its empty grammar, Absence appears as the space surrounding ideograms, and ideograms emerge from that empty source exactly like Presence's ten thousand things—a fact emphasized in the pictographic nature of ideograms, and no doubt the ultimate reason for that pictographic nature. Indeed, the ideograms are themselves infused with that emptiness, as they are images composed of lines and voids, Presence and Absence, a fact that becomes

important in calligraphic art, as we will see. So, rather than referring mimetically to some empirical fact, an ideogram shares that fact's embryonic nature. And again, this makes the true dimensions of a Chinese poem impossible to render in English where the language (thought/experience) undergoes a fundamental ontological shift from non-mimetic to mimetic.

This sense was no doubt often lost in day-to-day utilitarian uses of the language by artist-intellectuals in their highly textual bureaucratic and intellectual lives. That routine use of language would have created a rupture in the existence-tissue much like Western languages do (though without the West's metaphysical divide), hence the need for the spiritual practices of ancient China. One purpose of poetry (and, as we will see, calligraphy) as a spiritual practice was to carry words back to their source in Absence, the origin-tissue, and so to carry us back to our own source in the origin-tissue. It does this by investing language with as much emptiness as possible, distilling expression to the fewest possible ideograms, even as it animates that space to deepen the poem's spiritual depth and resonance. In addition, the most artistically engaged poems tend to be small, generally only four or eight short lines. Much like the movement of thought arising and then falling silent in Ch'an meditation, a classical Chinese poem is a glancing gesture that returns us promptly to that generative field of silent Absence. Here, one of Ch'an's most fundamental insights is revealed quite literally: when there are words, there is

no Absence. Words replace the deepest insight, which is simply the immediate experience of Absence itself. And so, poets often felt that a poem, however wise, was in the end a failure of wisdom.

But it was the least failure possible in language. By opening and animating the emptiness infusing and surrounding words, poems are always expressing the wordless. You can feel origins in such poems, dark origins where human culture and change itself begin. You can feel mind participating in that cosmological process of appearance emerging from mystery suffused in a shadowy field of Absence. It is another way of weaving identity and existence together into a single tissue here in the beginning.

Inkstone-Wander's poem doesn't distinguish Inkstone-Wander as an isolate center of consciousness. The *I* is an empty presence, as we have seen. It is as much Stone-Waves as Inkstone-Wander, especially when written in Stone-Waves' own distinctive calligraphic style, and it is as much us as either of those ancients. At the same time, the textual cosmology of Absence and Presence infuses that empty presence with vast cosmological depths; for in that empty grammatical space, identity is indistinguishable from Absence. And so, the poem returns identity to the source-tissue, meaning the empty *I* we share in this poem is nothing other than the source-tissue acting at the generative heart of the Cosmos. It is the source-tissue scratching its head in wonder, the source-tissue that is so near purple emptiness and gazing into sea-mist, that trails out the indigo-blues and kingfisher-greens of

mountain ridgelines, wanders separated and cut-off far from home and civilization in wild southlands beyond the Yangtze River. Poetic practice works exactly like landscape practice, weaving consciousness and landscape together, returning us to dwell here in the beginning where the existence-tissue is whole and not only aware of itself through the opening of consciousness, but also thinking itself, feeling itself.

9

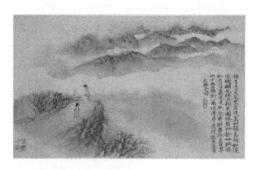

L IKE POETRY, the visual arts also give shape to this cosmology of Absence and Presence in ways that create it as an immediate emotional experience, that engage '心 as both a full heart and empty mind. The practice of calligraphy is similar to the practice of meditation. It changes our relation to language, the medium of identity; and finally, it reweaves identity into the existence-tissue. Normally when we read, we pay attention only to the black text itself. The empty space around it is

of no interest to us. It is quite different in classical Chinese, as we have seen, where linguistic Presence emerges from generative Absence. Calligraphic practice heightens this dramatically, for a gestural brushstroke (Presence) brings the empty space around it (Absence) to life, energizing it. The wilder and more artistic forms of calligraphy also animate and liberate the emptiness within the structure of each ideogram, opening and releasing it into the emptiness surrounding the ideograms, as in this quite typical moment from Huang T'ing-chien's calligraphic scroll in Plate 2, where the form of the ideogram 銀 unfurls into:

When a calligrapher first touches inked brush to a blank sheet of paper or silk, it is that originary moment where Presence emerges from Absence; and as the brushstroke traces through its arcs and twists, animating empty space, it is always at that originary moment. But this is not an originary moment in the sense of a beginning as it is conceived in our linear time, for here we encounter again that deeper and more accurate concept of time as an ongoing generative present in which Presence is perpetually burgeoning forth from Absence. And calligraphic

practice is a way of returning to the primal experience of moving there in that generative moment where the Cosmos perennially creates itself.

In calligraphic practice, the ongoing originary moment moves also in consciousness, for the calligrapher creates calligraphy with an empty mind, a mirror-deep mind that is the same space as the empty sheet of paper or silk. The dance of the brush at that originary moment therefore unfurls through the empty space of Absence in three realms that we normally separate but which are part of the same tissue: consciousness, page, and Cosmos. Chinese texts are written from top right down, and the strokes of individual ideograms are written from top left to bottom right. Reading calligraphy with an empty mind, mirroring it as a spiritual practice, a reader follows the dynamic line of the brush as if the focus of awareness were the tip of the brush in motion, and thereby shares the calligrapher's experience, inhabiting that originary moment where the ten thousand things well up into existence.

As with those primal artists chiseling petroglyphs into rock, it is in this originary space that calligraphers craft their personal expression. Calligraphy was considered a clear window into the profound levels of a person's character, and Stone-Waves' calligraphy reflects his own deepest dimensions, dimensions that are also represented in the painting as a whole. Stone-Waves' calligraphic transformation of the ideograms can be seen by comparing the calligraphic script from his painting with the poem in standard form opposite, written in the traditional sequence,

from top right down (and not including material appearing after the poem itself: Inkstone-Wander's name, the location, and Stone-Waves' signature):

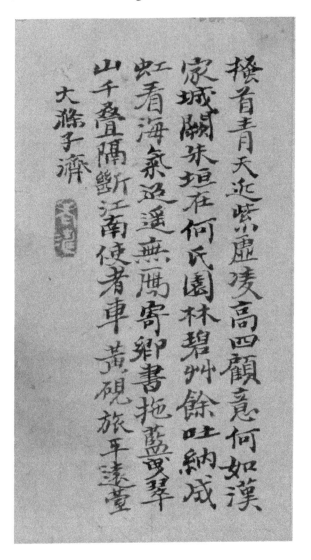

搔首青天近紫虛凌高四顧意何如漠

家城闕朱垣在何氏園林碧艸餘吐納成

虹看海氣迢遞無鴈寄鄉書拖藍曳翠

山千疊隔斷江南使者車

Stone-Waves' ideograms are somewhat misshapen, as if from the grief of exile, of living where home and civilization are lost in distances, and they reflect in their precision a mind that shares the severity of the season, with its cold sea-mists and bare branch-tangles. But at the same time, the ideograms have an effortless feel, which belies that grief and severity, and they seem infused with a good-naturedness and acceptance animated by a liveliness, an almost childlike whimsy. And finally, these dimensions combine to reveal a joyful energy and deep wonder at existence.

But this dimension of personal expression always springs from the spiritual dimensions of calligraphy as Ch'an practice, as the energy of the Cosmos made visible, for calligraphy's deepest artistic intent was to carry us back to the beginning, sculpting that space where we inhabit the existence-tissue wholly, each master inscribing a singular form of empty mind and full heart. This is calligraphy as a form of Ch'an practice in the same way that poetry was, and it too was sometimes spoken of that way: "calligraphy-*Ch'an.*" It was transmission of mind outside words and ideas. And as a Ch'an master, Stone-Waves no doubt thought of it like painting, as a way of teaching Ch'an.

Stone-Waves' writing is a quirky version of an ancient script known as "clerical" (隸), which perhaps gives it a sense of antiquity that is especially poignant at this moment when China had just been taken over by foreigners. Clerical script allowed very expressive possibilities, and Stone-Waves took full advantage of those possibilities to

render Ch'an insight in a singular way. But there is a wilder and more philosophically revealing form of calligraphy known as "cursive" (草: literally "grass," and here meaning something more like "a careless or hasty draft"). Huang T'ing-chien (1045–1105 C.E.), another accomplished Ch'an adept whom Stone-Waves surely revered as an ancient master, created a singular form of cursive script from which Stone-Waves no doubt learned deeply, for its spirit can be found in his calligraphy. One of Huang's calligraphic enlightenment moments came from watching the oar-strokes of rowers: long, steady, strong. And his calligraphy reveals a deep wisdom of exactly those characteristics, with the balanced power of its wander-and-wave forms, the long meander that shapes his lines so that in this detail from the scroll in Plate 2, 初入 becomes (reading top down) the intense and yet lazybones script below, where Huang is so unconcerned with convention that he doesn't bother to shape 入 with any more precision than a giant cross, meandering carefree and bemused and utterly self-assured in its power, all at the same time:

And 到 becomes:

This is subtly present in Stone-Waves' calligraphy, where lines are often overlong, thin and undulating. And Stone-Waves' quirky script, with its comically misshapen ideograms constructed of those strange undulating lines, is always informed by the same sense of whimsy and wonder as Huang's script. For both of them, this reflects a mastery of the technique of no technique. But at the same time, Huang's art as revealed in his *Li Po's "Thinking of Long-Ago Travels"* (Plate 2) contains its own very powerful character, reflecting his edgy but forceful self-assurance—determined and yet carefree, a little gnarled and cantankerous celebrating the profound and strange transformations his virtuosity can bring to the ideograms, transformations always informed by a Ch'an-inspired gleefulness. Huang's ideograms seem to take command of space, slashing and opening, and in them one feels that the insight of his virtuosity is vast as the entire Cosmos.

You can feel in Huang's cursive the basic structures of meaning and identity, the ideograms themselves, unraveling into abstract gestures and meaningless forms, another aspect of calligraphy's function as a form of Ch'an practice. Calligraphers were very aware of the pictographic dimensions of ideograms, so in a sense cursive calligraphic practice was a form of painting, for the ideograms begin as images representing the ten thousand things, which are then transformed into abstract gestures. At this deep level, calligraphy is truly a wordless practice. It doesn't matter much what the ideograms mean, and they are indeed often unreadable, for they are simply the material in an art-form that most closely resembles abstract-expressionist painting. What matters is that you can feel the liberating dance of ideograms trailing out through the spatial silence of Absence, returning meaning to the meaningless tissue of existence itself, identity become nothing more than existence rustling, decorating itself with wavelength festoon, wander-deep confetti, eye-lit celebration. And in that emotional space, you can feel empty awareness and the expansive presence of existence as a single tissue here in the beginning.

With his singular and profound sensibility, and the mastery of his brush, Huang T'ing-chien transforms this array of text from a Li Po poem (again reading in the traditional sequence, from top right down) into a dramatic, artistic composition:

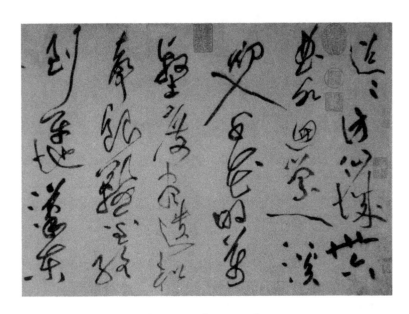

Color Reproduction: Plate 2

超超訪仙城三十六

曲水迴榮一溪

初入千花明萬

壑度盡松風

聲銀鞍金絡

到平地漢東

While such calligraphy renders the mental realm, it also renders the entire cosmological process, an achievement dramatically evident in the work of Huai Su (737–785 C.E.). Huai was a supreme master of wild-cursive script, a form that pushes cursive script to the extreme. Huang T'ing-chien once borrowed Huai Su's fabled *About Myself* (Plate 3) and copied it over and over for days, the deepest way of inhabiting the movements of a master's insight, and it brought Huang to a kind of enlightenment, the moment he fully mastered wild-cursive script. And Stone-Waves, too, no doubt revered Huai Su as an ancient sage teacher, just as Ch'an adepts would look back to great Ch'an masters. Like Stone-Waves, Huai Su spent many years as a monk in a Ch'an monastery, and he too became a Ch'an teacher of sorts. Eventually he left the monastery to pursue calligraphy, and several of his great moments of enlightenment happened outside the monastery. One came when he saw the calligraphy of Chang Hsü (ca. 675–759), the great wild-cursive master from the preceding generation. And at least one great moment of enlightenment came to him through landscape practice, on a day when he was watching the transformations of mountain peaks among the billowing emptiness of clouds and mist, not unlike those in Stone-Waves' painting.

As with Stone-Waves and Huang T'ing-chien and virtually all other calligraphers, calligraphy represented for Huai Su another way of practicing Ch'an. He felt that cursive writing was a practice wherein he achieved *samadhi*, the deepest form of meditation. In his calligraphy,

Huai so completely liberates himself from self-identity that personal expression meant for him a Taoist/Ch'an practice of selfless participation in the cosmological process.

Huai's wild-cursive script enacts the elemental forces of the Cosmos. In it, we can *feel* Presence tumbling through its myriad transformations like mountain peaks among windblown cloud and mist, appearing out of Absence as a dark ink-soaked stroke begins, twisting and folding as its form unfurls and evolves, sometimes headlong and sometimes lazy, sometimes thick and sometimes thin as it leaps and falls, writhing with the energy of a dragon, feathering into Absence as the ink dries up and emptiness sifts into the brushstroke, and then finally disappearing back into Absence where the stroke ends. That dynamic movement appears concisely in this detail from Huai Su's *About Myself* (Plate 3):

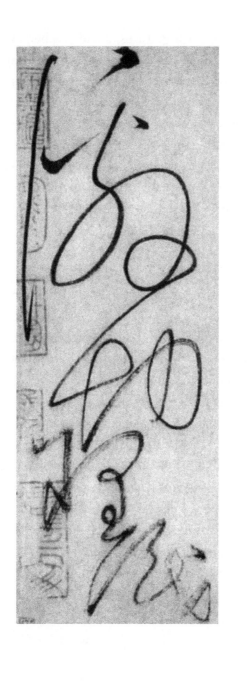

In creating such gestures, a calligrapher like Huai Su acted as a force of nature, moving with the same selfless energy as the Cosmos itself, enacting the essential movement of that magisterial cosmological process, the movement of dragon, both within consciousness and without. The brushstroke is always here in the beginning, at the ongoing originary moment of Presence burgeoning forth from Absence; and at the same time, as it unravels ideogram after sprawling ideogram, it opens the experience of words returned to Absence, the source they share with the things they "name" in our mimetic concept of language. This is to move with the spontaneity expected in a successful koan answer, making calligraphy a kind of answer to the Cosmos as koan. In following the movement of that brushstroke with the mirror-deep clarity of Ch'an empty mind, much as Huang T'ing-chien did when he copied Huai Su's *About Myself*, we experience thought and identity returned to the existence-tissue here in the beginning. We participate in an unbridled mind soaring free of the tangles that mire our lives in day-to-day concerns, a mind full of creative energy and elemental joy, wherein thought and identity and language are purified to the sheer energy of the Cosmos. Huai Su's *About Myself* (Plate 3) is one of the great examples of this. In it, we can feel Presence itself dancing through Absence here in the beginning, and Absence through Presence.

10

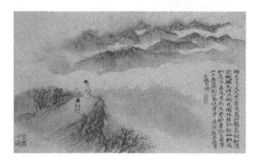

T HE PRIMAL COSMOLOGY of Absence
and Presence appears almost schematically
in virtually all landscape paintings. The pregnant empti-
ness of Absence takes the form of mist and sky, lakewater
and cloud, which is why they are generally rendered in
a single background color—a pale wash, raw paper or
silk—rather than in realistic colors: blue sky, white mist
and cloud, green-black rivers and lakes. Inkstone-Wander's

poem describes it this way too, describes him as an absent presence looking out at that emptiness, for 虛 (*empty*) is synonymous with Absence:

搔	首	青	天	近	紫	虛
scratch	head	green-azure	sky/heaven	near	purple	empti-ness

And so, the landscape practice portrayed in Stone-Waves' painting is described as a kind of meditative practice, wherein thought and identity give way to the immediate experience of that pregnant emptiness at the source of all things.

Meanwhile, Presence appears in paintings as the rivers-and-mountains landscape emerging from that emptiness of mist and cloud, water and sky—emerging and hovering there, seemingly on the verge of vanishing back into it. And the elements of this landscape are integrated through that emptiness, which associates them in a single tissue. In Western painting, those elements are rendered as discrete entities because they are shaped with hard boundaries and modeled out of different opaque colors. But in a Chinese painting, landscape elements not only inhabit a single field of emptiness, their forms are also often filled with that shared emptiness. In Stone-Waves' painting, this is true of the mountain ridgelines suffused in mist, the valleys wholly lost in mist, Inkstone-Wander and his attendant, and even the summit rock where they stand.

The principles of calligraphic practice form the basis of painting, where landscape elements are made of the same spontaneous brushstrokes we have seen in calligraphy, brushstrokes that embody in their dynamic movements the energy of Presence's burgeoning forth and ongoing transformation. Again, this is the same spontaneity that Ch'an masters demand in successful answers to koans, and so a painting too is like an answer to the Cosmos as koan. This takes the unusual form of a smoldering intensity in Stone-Waves' painting: the distant mountains, and in the foreground, bare trees and rocky cliff. But more often, it appears in the gestural energy of the brushstroke itself, as in a gnarled tree trunk with roots from Fan K'uan's *Travelers Amid Streams and Mountains* (Plate 1):

And a rock from Chao Meng-fu's *Twin Pines, Level Distance* (Plate 4):

A particularly dramatic example is found in Chang Feng's *Gazing at a Red-Leafed Maple Across a Ravine* (Plate 8), where the brushstrokes (Presence) are not only charged with calligraphic energy and infused with the empty space of Absence, where thin ink allows the background emptiness to open into the stroke itself. They are also so clearly calling attention to themselves as brushstrokes that the landscape illusion (Presence) they render threatens to dissolve into Absence at any moment. And fittingly, it is an autumnal scene, the figure gazing at the last few red maple leaves, a last bit of color before the blankness of winter, season of Absence.

In painting, as in calligraphic practice, the brushstroke always moves at that originary moment, an act

of perpetual spontaneity by the artist, and this further infuses painted landscapes with the energy of Presence burgeoning forth from Absence. Indeed, great painters, like calligraphers, were considered forces of nature, because in making a painting they moved at that ongoing generative moment with the same selfless creative energy as the Cosmos. And so, rather than rendering a realistic landscape, such paintings manifest in their every dimension the dynamic transformations of Absence and Presence in a generative Cosmos.

Like poetry and calligraphy, ancient Chinese landscape painting was also spoken of as a form of Ch'an: "painting-*Ch'an*." The making of a painting was considered a form of *Ch'an* practice, as described above, but so too was the viewing of a painting. A painted landscape was ideally viewed with the mirror-deep empty mind of Ch'an, a meditative practice in which a viewer might stand in front of a single painting for hours, absorbed in its depths of landscape and philosophical insight. When the ancients looked at a painting with a mirror-deep mind, they rehearsed empty awareness here in the beginning, exactly like Inkstone-Wander in Stone-Waves' painting. As they gazed mirror-deep into a painting, they felt within consciousness both the blank field of Absence and dynamic Presence emerging from that field, its forms chosen not arbitrarily or to portray a particular landscape, but for the resonance they open in 心, its empty mind and full heart. This way of experiencing a painting is encouraged by the complete lack of perspectival structure that fixes

the viewer at a single point *outside* of the painting's space. Instead, the painting includes us within its open space, the gaze of consciousness open and diffuse and able to wander the landscape freely. And in Stone-Waves' composition, this resonance is enriched by the poem that appears in the painting's empty space, with its description of dimensions not visible in the image.

The integration of human and nonhuman realms is also rendered pictorially in landscape paintings. Often, this integration is achieved by rendering the human realm (people, villages, monasteries) as a small part of the landscape, as woven into the vast expanse of existence, belonging to it: Chao Meng-fu's tiny fisherman on a thin slip of boat drifting across an empty expanse of lakewater (Plate 4); Hsia Kuei's lone traveler crossing a bridge, tiny in the midst of a vast and crystalline landscape (Plate 6); Fan K'uan's travelers half-lost in valley mist beneath the resounding presence of huge mountains (Plate 1), and above them a half-hidden monastery almost indistinguishable from broken rock and forest trees:

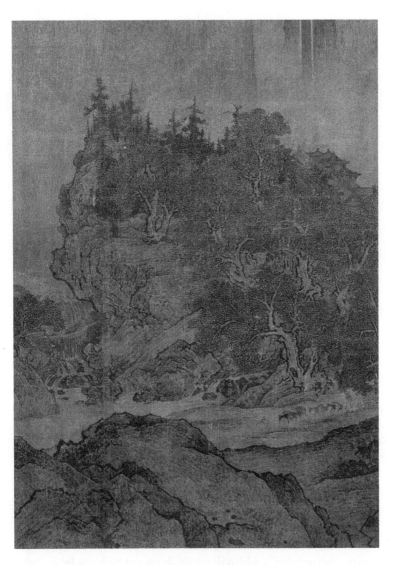

Detail from Plate 1

Another typical strategy—appearing in Stone-Waves'
painting, as well as Chao Meng-fu's and Hsia Kuei's—is to
model human figures out of the same emptiness that suf-
fuses the entire landscape. And these figures were always
drawn with the same calligraphic brushstrokes as every-
thing else in the painting, brushstrokes that embodied the
elemental energy of Presence burgeoning forth from Ab-
sence, and so suggest that the figure inhabits that primal
sense of time as an ongoing generative moment.

Painting, calligraphy, poetry: Stone-Waves' master-
piece embodies the essential unity of the three arts as
spiritual practices, creating a single aesthetic world of re-
markable cosmological depths. The poem emerges from
the painting's field of Absence just as the landscape does.
This happens not only in the dynamic calligraphic gestures
of its script, but also in the poem's empty grammatical
space, which is identified with the painting's empty space
of pale mist. Here again we recognize the assumption that
the subjective realm of thought and language and identity
participates in the same existence-tissue as the objective
realm of landscape, an assumption supported by the pic-
tographic basis of ideograms. It is the same insight that
the practice of meditation reveals: objective and subjec-
tive realities emerge from the same generative source and
with the same ontological status, evolve according to the
same principles, and finally vanish together back into that
source-tissue.

Like poetry, painting grows out of the assumptions
of *I Ching* hexagrams, which are a hybrid of visual and

linguistic expression intended to embody the inner forces and processes shaping reality. Like words in a poem, the elements of landscape in a painting do not portray reality in the mimetic sense that we in the West take for granted. Traditional paintings in the West function as ontologically separate realms portraying the world from outside, much like language, thus embodying our dualistic assumptions about human consciousness existing fundamentally outside of empirical reality. But paintings like Stone-Waves' do not depict a realistic landscape seen from outside by a center of identity, and they do not aspire to beauty. Instead, they depict the inner forces and processes shaping the ten thousand things. They depict a landscape's 意 (*yi*), the "intentionality/intelligence/desire" ordering its unfolding. Or to use another philosophical term closely related to 意, they depict a landscape's 理 (*li*), its "inner pattern." They also depict the other principles that describe the existence-tissue at the most foundational level: Absence and Presence, Tao, *tzu-jan*. And to create a great painting, the artist (like a poet or calligrapher) must internalize 意 and 理, must move at the foundational level where human consciousness and action are integral to the movements of Absence and Presence, Tao, *tzu-jan*.

And so, like Chinese poetry, Chinese painting as spiritual practice reveals a form of experience fundamentally different from what we take for granted. It is experience free of the dualisms that shape our immediate experience, much like the petroglyphs with which existence

decorates itself. But it does not depict those foundational principles in some metaphoric way; it depicts them directly: it *enacts* them. A painting is itself the Cosmos in microcosm, alive with those cosmological principles of Absence and Presence; and as in a poem where grammatical emptiness extends out into the space surrounding the poem's brief utterance, the emptiness of a painting extends by suggestion beyond the picture frame, suggesting the vastness of the Cosmos. And gazing at it with a mirror-deep mind, as the ancients often did for hours at a time as a form of deep spiritual practice, we are returned to dwell here in the beginning, where consciousness and landscape are woven together in a single existence-tissue, where we experience the dynamic Cosmos in a complete and distilled way rarely possible in ordinary life: whole and with perfect immediacy.

Ancient China's landscape paintings return us to the emotional dimensions of this experience through two opposing strategies: one of resounding Presence and the other of resounding Absence. The strategy rendering Presence, which historically preceded the second, portrays mountain landscape in ways that emphasize its grand scale and drama, making us feel existence in all its overwhelming dimension and power: vast and deep, everything and everywhere. Fan K'uan's archetypal *Travelers Among Streams and Mountains* (Plate 1) is perhaps the most renowned example of this in the tradition. Gazing into it with an empty mind and a full heart, the ancients

gazed into the existence-tissue in its most magisterial dimensions.

The second strategy, quite the opposite of the first, is a kind of landscape minimalism, as in Chao Meng-fu's *Twin Pines, Level Distance* (Plate 4), which creates a different kind of vastness: that of emptiness. Rather than rendering landscape realistically as in traditional Western landscape painting, filling pictorial space with paint to create an illusion of real landscape, a Chinese painting generally contains a great deal of empty space. Here that impulse is pushed to its most extreme limit: generative Absence is a resounding expanse, with only the faintest traces of landscape (Presence) standing out from it. This encourages us to feel the particular thusness of things because they stand out dramatically against the surrounding empty space, thereby intensifying the individual presence of each of them, as if illustrating Lao Tzu's principle of *tzu-jan*. But it is perhaps even more powerful in opening awareness to Absence. It creates a meditative experience wherein empty-mind mirrors the ten thousand things with particular clarity, but what primarily fills mirror-deep mind are the empty depths of Absence.

These two strategies—minimalist clarity and magisterial drama—appear in myriad combinations across the painting tradition, each particular combination creating its own unique emotional configuration of dwelling here in the beginning: the Stone-Waves painting, for example, its poem explicitly registering both minimalist emptiness and awe at cosmological grandeur:

Scratching my head in wonder, all green-azure heaven,
 I'm so close here to purple
emptiness. On these cold heights, four vistas opening
 away: what are thoughts like?

And there are countless other examples, such as those found in Plates 5–9.

11

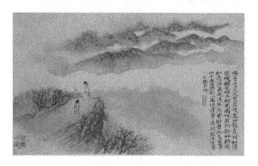

THE COSMOLOGY of Absence and Presence structures everything in ancient China. It defines the physical structure of the Cosmos, with the empirical world emerging from a generative emptiness; the compositional structure of calligraphy and painting, with their forms emerging from that same emptiness and vanishing back into it; the structure of language and poetry, with their empty grammar and pictographic words emerging at the empty source of things, the ideograms themselves nestled around the empty space

within them; the structure of consciousness, in which thought emerges from a generative emptiness and returns to vanish there; and finally, it structures perception, where empty mind mirrors empirical reality.

This cosmology of Absence and Presence is the simplest and most magisterial approach to the fundamental nature of existence. But sage insight understands that the story of existence, like any other idea or explanation, is mere story; that finally, deep realization means seeing through ideas and explanations. The first koan in the *No-Gate Gateway* collection (see p. 44) calls our everyday preoccupation with thoughts and ideas and explanations the "mind-road," and goes on to say that "if you don't cut off the mind-road, you live a ghost's life, clinging to weeds and trees." That dichotomy of Absence and Presence represents the most profound and all-encompassing of koans, teasing the mind past ideas and explanations at the most profound cosmological level; and it is indeed the deep subject of the *No-Gate Gateway*'s first koan,[*] which is described as the great gateway into Ch'an enlightenment. In the koan, a monk asks about the Buddha-nature of a dog, and the master mysteriously replies: "Absence." So it is Absence that the koan asks us to ponder, and the koan's commentary advises us: "Don't understand Absence in terms of emptiness, and don't understand it in terms of

[*] For further discussion of this crucial koan, see my *Mountain Home*, pp. 122 ff. and *No Gate Gateway* (forthcoming).

Presence." Finally, the commentary's summation poem says:

A dog, Buddha-nature: the whole
kit-and-caboodle revealed in a flash.

Think of Presence and Absence,
and you're long lost without a clue.

The dichotomy of Absence and Presence is a puzzle that offers a way past ideas and concepts at the most fundamental level, a way to return and dwell as an integral part of the existence-tissue here in the beginning: vast and whole, everything and everywhere.

Luckily, the puzzle is not so difficult. Absence was often referred to as "emptiness" (空 or 虚), as in the koan's commentary and the first line of Inkstone-Wander's poem, and described as the generative void from which the ten thousand things (Presence) are born and to which they return. Our language and intellectual assumptions have trained us to interpret such terms—Absence, emptiness, void—as a kind of nonmaterial metaphysical realm in contrast to the material realm of Presence. We interpret Absence and Presence as a dualistic pair, in which Presence is the physical universe and Absence is a kind of metaphysical womb from which the physical emerges.

But Stone-Waves would not have recognized any metaphysical dimensions in this dualism, for like all artist-intellectuals in ancient China, he was a thoroughgoing empiricist. And in the empirical reality of the Cosmos

there is no metaphysical womb, no pool of pregnant emptiness. Absence is emptiness only in the sense that it is empty of particular forms, only absence in the sense that it is the absence of particular forms. Taken alone, the ideogram for Absence (無) means something like "(there is) not," and the ideogram for Presence (有) literally means "(there) is." So the concepts of Absence and Presence might almost be translated: "formless" and "form," for they are just two different ways of seeing the existence-tissue. Absence is all existence seen as one undifferentiated tissue, while Presence is that same tissue seen in its differentiated forms, the ten thousand things.

As it is generative by nature, magically generative, the existence-tissue is perennially shaping itself into individual forms—the ten thousand things—and reshaping itself into new forms: the natural process of life and death, transformation and rebirth. From this it follows that Absence and Presence are not two separate realms of reality, but are instead a single tissue, all origins through and through. The existence-tissue took shape as humankind, as well as the other higher animals; and to survive originally as scavengers and hunter-gatherers, we needed to engage knowingly the individual forms taken by the existence-tissue. They filled our vision, a process greatly intensified by language with all of its words naming the ten thousand things, and we gradually lost our ability to see the existence-tissue as a whole.

To see Absence and Presence together as a single tissue: that transforms things completely, for the fundamental dichotomies structuring everything vanish. Absence and Presence, generative emptiness and the ten thousand things, become a single tissue. A calligrapher's brushstroke and the empty space it animates become a single tissue. A painter's landscape and the emptiness suffusing it become a single tissue. Word and silence become a single tissue, as does meaning and meaninglessness, self and Cosmos. Thought and empty mind become a single tissue. Mirror-deep empty mind and the ten thousand things filling perception become a single existence-tissue.

Unharvested pears and apricots, sunlit green and yellow, frost-blackened. Crumbling city walls, gate. Mist alive with empty purples. Crimson walls. Tumbledown houses. Mountains, a thousand ridgelines indigo-blues and kingfisher-greens. Green-azure sky appearing and disappearing. Winter-charred orchard tangles, lit for a moment, then charcoal-dark again. Chrysanthemums ablaze, then clotted with swollen dark.

12

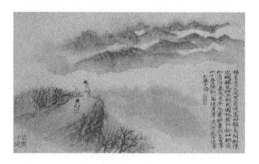

THERE WERE NAMES for that undifferentiated existence-tissue. One of those names was *dark-enigma* (玄), which Lao Tzu uses for the impossible task of naming this tissue as it is in and of itself before any names, before Absence and Presence give birth to one another, and before all the other words and concepts and distinctions we use to approach the nature of existence: *existence-tissue, Tao, tzu-jan, heaven and earth, yin and yang*. This dark-enigma is described perfectly at the end of the *Tao Te Ching*'s first poem:

In perennial Absence you see mystery,
and in perennial Presence you see appearance.
Though the two are one and the same,
once they arise, they differ in name.

One and the same they're called *dark-enigma*,
dark-enigma deep within dark-enigma,

gateway of all mystery.

Dark-enigma is a return to consciousness prior to language and the utilitarian differentiation of things we need for survival. It is, in a word, the existence-tissue here in the beginning when we open our eyes to find there is no distinction between consciousness and empirical reality, when we find they are a single whole: vast and deep, everything and everywhere.

As soon as you conceptualize it, name it even with this first name, *dark-enigma,* that immediacy and wholeness is lost. Dark-enigma can only be known in immediate experience, which is immediate experience here in the beginning, here where there is no conceptualizing or knowing. But it is possible to suggest the nature of this experience, as Lao Tzu does at the end of his first poem. Dark-enigma cannot be portrayed directly because it is exactly the generative existence-tissue prior to the distinctions of forms, of names, or even of consciousness separate from things; but that immediate experience of dark-enigma is suggested everywhere in landscape paintings.

The dark-enigma tissue cannot be known in the realm of distinct forms, nor can it be known in the realm of formlessness, because formlessness precludes knowing. But it can be glimpsed where forms are in the process of appearing out of or disappearing into the emptiness of formlessness. Hence, the nature of Chinese landscape paintings, with their forms blurred at the edge of appearance and disappearance, dark even if that blur is usually full of light: mountains half hidden in mist; villages almost lost in lacustrine distances; things themselves—rocks and trees, mountains and houses and people—suggested only by sketched outlines and otherwise more formlessness than form. And seen with a mirror-deep mind, this blurring is also the blurring of consciousness back into the undifferentiated existence-tissue. The pictorial suggestion of dark-enigma, of the existence-tissue without form, is especially dramatic in Stone-Waves' *Between River and Mountain*, where the blurring of things into an emptiness of water and mist seems to be in the process of being consumed by a field of black ink swelling and obliterating form with the shadowy tissue of dark-enigma, thereby making dark-enigma itself the subject of the painting:

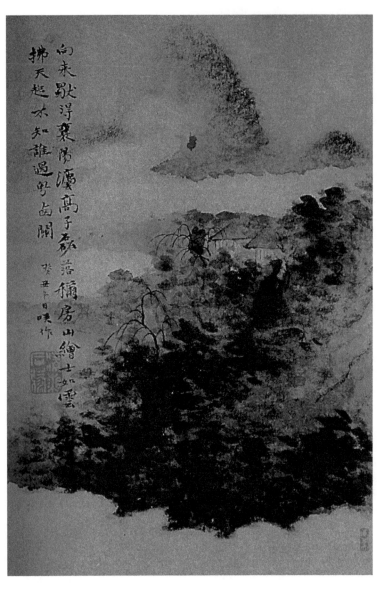

Shih T'ao: *Between River and Mountain* (1667)

Palace Museum, Beijing

13

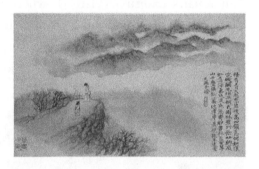

THERE IS ANOTHER name for Absence and Presence recognized as a single entity, a concept that emphasizes its nature as a living tissue: 氣 (*ch'i*). 氣 is often described as the universal life-force breathing through things. But this presumes another dualism, for it separates reality into matter and a breath-force that infuses it with life. That may be useful like Absence and Presence as an approach to understanding; but more fully understood, 氣 is both breath-force and matter simultaneously. It is a single tissue generative through and

through, the matter and energy of the Cosmos seen together as a single breath-force surging though its perpetual transformations (an insight confirmed in Einstein's $E = mc^2$ where energy and matter are interchangeable). This is clearly visible in a closer view of the travelers in Fan K'uan's painting (Plate 1), where everything seems dramatically alive with an elemental force: tree trunks, streams, leaves, and most notably perhaps the rock, which seems almost molten, full of life and movement:

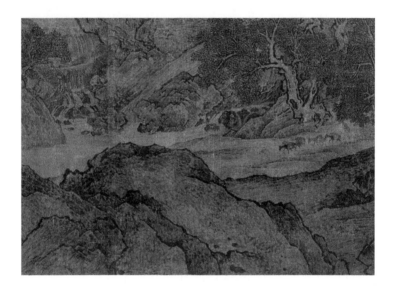

This elemental *ch'i*-force is no different from dragon. And it is no different from this living existence-tissue we encounter when we open our eyes with Inkstone-Wander and Stone-Waves here in the beginning before names and concepts, stories and explanations, where it is clear that

consciousness too (however empty it may seem in relation to the physical world it perceives and contemplates) is made of 氣, and is therefore woven utterly into the tissue of existence.

Even with its very limited palette, Stone-Waves' painting is quite colorful as Chinese landscape paintings go. A typical landscape painting uses only black ink on a ground of pale neutral washes or the natural color of paper or silk because that was the most eloquent way to render landscape not as a surface composition of form and color, but as a generative cosmological tissue. Of course, the ancients could see all the gradations of color in a landscape, but they also saw the landscape through a color concept that reflected this sense of landscape as a single cosmological tissue: 青. 青 essentially meant the color of landscape, and covers everything from the greens of trees and nearby mountains through the hazy blue of distant mountains to the azure blue of sky, and even includes the blacks of dusky forests and mountains. And by adding hints of this color sense to the traditional framework of black ink on a neutral ground, Stone-Waves creates a unique rendering of Absence and Presence as a single undifferentiated *ch'i*-tissue.

In this he succeeds in painting's deepest aspiration, an aspiration that gives the painting a strange appearance in other ways as well. The ridgelines seem alive with writhing dragon-forms, an elemental *ch'i*-energy that we might describe as geologic. That same energy also animates Stone-Waves' calligraphic forms, erasing once again the ontological distinction between the empirical realm and

the realm of thought and language. Indeed, the painting's writhing calligraphic forms reveal language as a living organism of image and meaning and sound, an integral part of the *ch'i*-tissue. And the sea-mist swelling up and enveloping the mountains is described in Inkstone-Wander's poem as "sea-*ch'i*," for it is a place where that ethereal tissue of *ch'i* is just condensing into a visible form but still retains something of its own character. Hence, it becomes almost visible: an unusual moment in the unfurling of *ch'i* as it coalesces into landscape and consciousness and all the other ten thousand things, coalesces for a time and then thins away again. We see this process in the painting—dragon-mountains seething with life-energy appearing from and disappearing into the emptiness of that "sea-*ch'i*," emptiness that is also seething with life.

When we encounter this "sea-*ch'i*" in Inkstone-Wander's poem, we also encounter once again identity as an absent presence in the grammar:

吐	納	成	虹	看	海	氣
exhale	inhale	city	rainbow	gaze	sea	*ch'i*

This absence makes the line an act of meditation, because without a subject for 看 (*gaze*), it describes empty-mind mirroring the "sea-*ch'i*," mirroring 氣 made visible. As we saw before, grammar offers the alternative that it is the rainbow looking, thereby blurring the distinction

between the rainbow and the absent *I*. And rainbows were considered a miraculous kind of interference pattern created by the mixing of ascending earth-*ch'i* and descending heaven-*ch'i*. This is experience at a very primal level in this cosmology, revealing that empty consciousness is not emptiness, but an ethereal configuration of 氣. We are ripples in the ceaselessly unfurling 氣 tissue, brief distillations in this single tissue that is the Cosmos, as are each of the ten thousand things, as well as each poem and painting and calligraphic composition. Experiencing oneself as an integral part of the *ch'i*-tissue is difficult to sustain. It is the purpose of spiritual practice in ancient China, and is no doubt why the first-person subject of poems generally appears as an absent presence integrated with the *ch'i*-tissue rendered in the poem.

This *ch'i* cosmology allows no origins in the sense of a beginning from which existence came. Instead, everything everywhere is always origin, which is why *ch'i* is also known as origin-*ch'i* (元氣). When Lao Tzu says "the unnamed is origin to all heaven and earth," he is not talking about a first origin from which heaven and earth came. He is talking about the tissue of origin-*ch'i*, the generative tissue that is perennially raveling itself into the ten thousand forms, perennially unraveling those forms and re-raveling itself into new forms. Here again we encounter that primal experience of time, not as linear or a metaphysical river, but as an ongoing generative moment. Or more precisely, as a *place;* for in this cosmology, time

and space are unified into a single tissue. It is a *ch'i*-tissue that is itself pregnant through and through; and so is itself the ongoing origin of change and transformation.

This is Lao Tzu's Tao, which we described as an ontological path*Way*, a generative cosmological process of transformation, and which we can now describe a little more deeply as this generative tissue of origin-*ch'i*. Although it is everywhere and everything we experience, we cannot conceptualize it, cannot name it. This is true both because it is all form and no particular form at all; and also because as soon as we name that tissue in and of itself, it eludes us completely. Known this way, outside name and concept as an "unnamed origin," it is nothing other than the "perennial Way." Rendering this unnamed perennial Way is a primary goal of Chinese landscape paintings, and indeed we can *feel* in them the unnamed and magisterial mystery of the perennial Way. When humans are evident, they inhabit that mystery—either because form and color unifies them with the mystery, or because they are pictured as tiny elements in the vastness of that mystery. Great painters worked as that same origin-*ch'i*, which is why they were described as forces of nature. And paintings not only represent the *ch'i*-tissue; they were themselves that *ch'i*-tissue. Like language, a painting is not mimetic. Instead, it enacts that emergence from the source exactly like the ten thousand things it portrays.

Stone-Waves' *A Mountain Hut* portrays this *ch'i*-tissue in a very dramatic and elemental way, together with the

unity of consciousness and landscape in *ch'i*. It renders up close the geological *ch'i*-energy of the dragon ridgelines filling Inkstone-Wander's gaze, almost as if someone had wandered out into those ridgelines and stopped at an empty hut:

Shih T'ao: *A Mountain Hut*, from *Landscapes for Yü Tao-jen* (ca. late 1680s). Album of 12 leaves.

C. C. Wang Family Collection

The person in the hut must ostensibly be Yü Tao-jen, to whom Stone-Waves dedicates the painting. But again, at a deeper artistic level, it is of course Stone-Waves himself gazing into the existence-tissue: a rocky mountain slope alive and seething with *ch'i*, the cosmological energy that courses through and is everything. It feels like the writhing energy of dragon (seen also in the mountain forms of Plate 9 that, again, almost feel as if they are lifting off to soar on a vast wind), like *waves of stone*. The stone itself appears molten and protean, so it seems almost as if we are seeing this *ch'i* energy across geological time frames in this painting, almost as if we are looking at hundreds of millions of years compressed into a single moment (and the Chinese were well aware of vast geological transformation from very early times, appearing in poetry with such images as mountains wearing away into seabeds, and seabeds rising to become mountain summits). The forms here are modeled in "dragon-veins," currents of *ch'i*, and they feel almost sexual. That would make sense because *ch'i* is engaged in regeneration and transformation, and it is often described as having two dimensions: *yin* and *yang*, female and male—whose dynamic interaction produces the cosmological process of change.

As we have seen, there is no difference between us and this *ch'i*-tissue: consciousness too is made of *ch'i*, whether it is empty or crowded with the unending transformations of thought and emotion, memory and perception. This fact

is rendered beautifully by Stone-Waves in this painting, for he is not just gazing out at the *ch'i*-tissue, but dwelling within it. He is, indeed, made of the same kind of emptiness and dynamic brushstrokes. And further, there is the meaning of his name, which suggests that he inhabits here the existence-tissue at the deepest possible level: Stone-Waves both inhabiting and gazing into waves of stone.

14

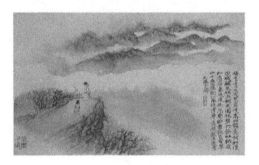

I N ITS MOST FUNDAMENTAL nature as
a single generative tissue, vast and deep,
everything and everywhere, the *ch'i*-tissue in and of it-
self cannot be experienced through things themselves,
for it is the undifferentiated ground of things. Like dark-
enigma, it can only be glimpsed in that space where
things blur between appearance and disappearance,
where Presence and Absence become visible as a single
tissue. For the ancients, this seemingly impossible rev-
elation is most available in mountain landscape, which

is why it so preoccupied artist-intellectuals. As with most all Chinese landscape paintings, this is what Stone-Waves' painting renders at its deepest level. In it, mountain ridgelines feel alive with *ch'i*-energy. Hovering in that space where forms blur and bleed out into the empty mist around them, they are suffused in the emptiness of those billowing mists, appearing as if just emerging from that emptiness and at the same time on the verge of vanishing back into it. All of the different landscape forms are integrated into a single tissue by that emptiness of mist and sky. Even if the mountaintop where Inkstone-Wander stands feels substantial for the moment, mist is swelling up out of the valleys all around it. Already the bare trees around him have begun vanishing into it. Soon it will no doubt inundate the summit and Inkstone-Wander himself, so he too inhabits that space between appearance and disappearance. And indeed, both Inkstone-Wander and the rocky summit are themselves already made of the same emptiness as the mist, for they are both composed of the same pale wash that defines the mist.

Poetry and calligraphy combine with the painterly elements of Stone-Waves' composition to form a single whole revealing the *ch'i*-tissue, that foundational existence-tissue. Suffused as it is in grammatical emptiness, Inkstone-Wander's poem also operates in that space where things are appearing and disappearing. It is poetry's deepest spiritual intent, just as it is painting's: to reveal the *ch'i*-tissue and our dwelling as integral to it. In

reading Inkstone-Wander's poem, there is the sense that meaning must be drawn out of the surrounding mist, that meaning is hovering on the edge of that emptiness and about to vanish back into it, that empty mind is there at the boundaries of its true wordless form. So even while the poem expresses human concerns, the very texture of its language opens the immediate experience of the *ch'i*-tissue word by word. Here again, poetry pushes the Chinese language's potential to its furthest extent, and reveals itself as a spiritual practice. And Stone-Waves' calligraphy does the same thing in the visual realm, for it infuses words with the dynamic energy of *ch'i* as they appear from and disappear into the surrounding emptiness, articulating that space between form and formless where the *ch'i*-tissue can be glimpsed.

Inkstone-Wander's poem, operating as an integral part of the painting, opens this space even wider, for it suggests a deserted and crumbling city with its houses and gardens not only literally disappearing back into the undifferentiated tissue as they fall into ruin, but also completely disappeared somewhere in the empty mists of the painting's composition, mists resounding with cosmological depths. Here we encounter the raw elemental sweep of the *ch'i*-tissue, revealed as perfectly indifferent to the tragedies that ravage human life. Its grand and elemental transformations go on regardless of our human hopes and sufferings and griefs, which are only a small ripple in that ongoing cosmological process.

To look into this tissue of indifference is a vision transformative in its terrifying and beautiful clarity, and it is the place sage insight in ancient China ultimately inhabited. Not only did dynasties rise and fall, bringing the kind of human suffering evidenced by the ravaged houses and cities in Inkstone-Wander's poem. But even the painting's exquisite mountain landscape is a realm of destruction within destruction, the scene of vast geological transformations, a concept the ancient Chinese understood well. Dark-enigma, existence-tissue, *ch'i*-tissue: whatever we call it, it is perfectly indifferent to the destruction these transformations bring about, and the empty mind that gazes out mirror-deep is also perfectly indifferent. How disconcerting and yet liberating in a way, that here in the beginning, where there is no distinction between empty-mind awareness and existence, this tissue of indifference is revealed as our own deepest and most complete identity. How disconcerting to cultivate that identity as we witness not just endless war and poverty, but also vast environmental devastation as we subject the planet to an epochal event of mass extinctions.

Sage insight was not about attaining some kind of nirvana-bliss; it was a matter of cultivating the fullest heart and emptiest mind, which comes from experiencing this world from the perspective of that existence-tissue itself, of the Cosmos as a single tissue of *ch'i*. The painting's cultivation of this sage insight culminates in the final couplet of Inkstone-Wander's poem:

拖	藍	曳	翠	山	千	疊
drag	indigo	trail-out	kingfisher-green	moun-tain	thousand	folds

隔	斷	江	南	使	者	車
sepa-rated	cut-off	river	south	employed	(those who are)	carriage

Here the subject for the verbs *drag* and *trail-out* would appear to be Inkstone-Wander (or Stone-Waves, or: *you, he, we, one*), especially as the verbs both contain pictographic elements suggesting human action: a hand and a long tool or weapon that one might drag on the ground. And the following line seems to continue describing that human subject. But as usual, it is an empty presence that allows no distinction between a center of identity and the existence-tissue: *[I] drag indigo-blues, trail out kingfisher-greens of thousand-layer mountains.* This empty presence is enriched by the realization that the subject is more likely the thousand-layered mountain ridgelines that appear to be trailing out their own indigo-blues and kingfisher-greens across the earth: *Thousand-layer mountains trail out their indigo-blues and kingfisher-greens.*

Hence, the empty *I* and the mountains are woven together, and this weave continues into the following line, where the subject for the verbs *separated* and *cut-off* appears most logically to be Inkstone-Wander because he is traveling south of the Yangtze, far from those sage officials he

imagines riding fine carriages through their active lives as important government and cultural figures in the northern capital of the now devastated Ming, officials he no doubt conceives as kindred-spirits devoted to benevolent and native-Chinese rule. But grammatically, it should be the mountains of the previous line that continue on as the subject of this line. And of course it is also true that the southern mountains are themselves *separated* and *cut-off* from civilization and the former capital in the north.

While the situation certainly entails a loneliness and sorrow, it is also enlightening, for here Inkstone-Wander has become indistinguishable from the mountains, indistinguishable from the existence-tissue itself:

> A thousand layered ridgelines, [I] trail out
> kingfisher-greens and indigo-blues
> here in these distances south of the river, far from
> sages in official carriages.

This identity with mountains represents the resolution of the poem and painting, for in this identity he takes on the nature of a mountain. But here, that grammatically absent subject involves Stone-Waves in a very powerful way, because among the sites illustrated in Stone-Waves' series of paintings following Inkstone-Wander's travels, this one is identified as the place where Stone-Waves' father was murdered in the fighting that accompanied the fall of the Ming Dynasty. In fact, the ruins described in the poem may well have included the remains of the palace where

Stone-Waves' father tried to establish himself as the new emperor in a last ditch attempt to continue the dynasty with its Chinese self-rule, the palace where Stone-Waves' family was slaughtered while he miraculously survived when a servant slipped away, carrying him to safety. It is a situation that allows the deepest of insights. The heart-mind of those mountain ridgelines is perfectly at ease even with slaughtered families and devastated civilizations and life at such lonely distances from human companions. And perhaps this explains the presence of that rainbow ironically arched up altogether too beautifully above a ruined city vanished in empty mist.

15

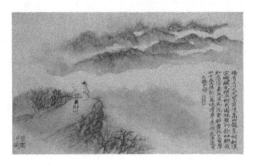

ABSENCE AND PRESENCE are a single existence-tissue: the ten thousand things are not born out of Absence, never separate from Absence. And it's the same for us. It might seem that we are born out of Absence, that in death we return to Absence, which would be homecoming enough. But we are always part of Absence, always *unborn*, as the ancients said. Our lives are simply ripples in the movement of the existence-tissue; and so those ancients saw death not as a grand personal tragedy, but as a natural transition in that movement. Death is

only a problem when seen from the self-involved perspective of personal identity, but in fact the existence-tissue itself is our truest self.

However separate the center of identity may seem, with its thought and emotion and memory, it too is part of the existence-tissue, wholly unborn. The perennial need for native readers of Chinese poetry to conjure an *I* in the empty grammar is a spiritual practice, a constant cultivation of this insight about our unborn nature, for just like ruins and mountains among billowing mists, that *I* keeps slipping in and out of view. Occasionally, Chinese poets fill the empty grammatical space with a pronoun *I*; and this pushes that spiritual practice even further, in a counter-intuitive way, because rendering the *I* in the grammar becomes a way of accepting the center of identity not as a problematic isolation from the existence-tissue, but as an integral part of the indifferent existence-tissue, as unborn. And translating a poem like Inkstone-Wander's creates much the same effect where English requires that the empty grammatical space of Chinese be replaced with the pronoun *I*:

> Scratching my head in wonder, all green-azure heaven,
> I'm so close here to purple
> emptiness. On these cold heights, four vistas opening
> away: what are thoughts like?

Existence rustles. It wants individuation, identity. Like any other ancient artist-intellectual, Stone-Waves

would describe the center of identity that way, as a particular condensation of *ch'i*-energy (hence the absence of a discrete transcendental *I* in poems). There is no inside and outside. Identity with all its distances, its apparent separation from the world, with its distractions and self-absorption—identity too is an unborn part of the existence-tissue, even if it is a failure of the existence-tissue to experience itself as whole.

This experience of our unborn nature, this experience of ourselves here in the beginning where empty awareness and the expansive presence of existence are whole: that is the real subject of Stone-Waves' painting. The painting returns us to a primal place where the existence-tissue is wholly open to itself. It returns us to dwell here in the beginning, unborn, where indifferent existence rustles, where it wants to know itself, to recognize itself in all its beauty and destruction. This is a place beyond saying, but Stone-Waves' painting somehow manages to conjure it up. With its painterly, poetic, and calligraphic dimensions integrated into a single composition, the painting is an extremely sophisticated creation, almost inexpressively deep in its artistic and philosophical meaning. And yet, it is not fundamentally different from cairn or petroglyph. If we are unborn, whatever meaning we create is also unborn, so Stone-Waves' painting with all its complexity is as perfectly meaningless as a cairn that recognizes and celebrates and yet says nothing, for it *means* everything around it. Meaningless as those petroglyphs with which existence adorns itself.

Identity is unborn, and with it, meaning too is unborn. It is not a separate realm, the isolate mental activity of a transcendental soul. And it is not a stable outside account of existence, as the Western intellectual tradition assumes, even if it does measure and describe and explain existence. Instead, it is existence's way of knowing itself, and so is no different than any other meaningless twist in the vast movement of the Cosmos: autumn wind tumbling leaves out of pear and apricot trees, mountains welling up from sea bottoms. There is no outside, no elsewhere. Words too are configurations of *ch'i*-breath, movements of the *ch'i*-tissue, of the Cosmos. This sense of meaning as integral to the *ch'i*-tissue, inside rather than outside, opens a deeper understanding of 意 (*thought/ intent*) in the second line of Inkstone-Wander's poem:

凌	高	四	顧	意	何	如
icy	height	four	views	thought/ intent	what	like

Rather than translating it as "thought," it seems more accurate to use "*ch'i*-mind," which opens the cosmological context for the idea of an "intelligence" that infuses the existence-tissue and of which human thought is but one manifestation. Language and thought/identity are not a transcendental realm looking out at reality and representing it mimetically, as we assume in the West. Instead, they are woven wholly into the ever-generative *ch'i*-tissue, unborn.

Existence rustles. It shapes itself into mountains

trailing out indigo-blues and kingfisher-greens, and those mountains explain nothing, mean nothing. It shapes itself into meaning the same way—for isn't meaning a remarkably successful evolutionary adaption? It tells its story, speaking in its own voice whole and complete as silence. It decorates itself with meaning, and meaning explains nothing, means nothing, exactly like those seething ridgelines, sea-mist, and city ruins. Meaning is, in the end, meaningless. Stone-Waves' painting is meaningless. Lao Tzu's poem distilling the whole story of existence, all of that insight, into a few seminal lines—it too is wholly inside, wholly meaningless:

A Tao called Tao isn't the perennial Tao.
A name that names isn't the perennial name:

the named is mother to the ten thousand things,
but the unnamed is origin to all heaven and earth.

In perennial Absence you see mystery,
and in perennial Presence you see appearance.
Though the two are one and the same,
once they arise, they differ in name.

One and the same they're called dark-enigma,
dark-enigma deep within dark-enigma,

gateway of all mystery.

And Inkstone-Wander's poem, telling the story of existence as it so profoundly describes the experience of inhabiting this cosmology at the deepest level, facing it, wide

open to all its creation and destruction—it too is as meaningless as the landscape it describes:

> Scratching my head in wonder, all green-azure heaven,
>> I'm so close here to purple
> emptiness. On such cold heights, four vistas opening
>> away: what is *ch'i*-mind like?

> Abandoned houses, city-wall gates, nothing left
>> unbroken but a crimson wall: who
> once tended these family orchards and gardens now
>> tangled in emerald wildgrass?

> A rainbow over the city breathes in and out of
>> view. Billowing sea-*ch'i* mist swells
> clear through distances, distances, my old village lost,
>> and no geese to carry letters

> home. A thousand ridgelines beyond ridgelines, I'm all
>> kingfisher-green and indigo
> blue trailed out south of the river, cut-off, far from
>> long-ago sages in fine carriages.

16

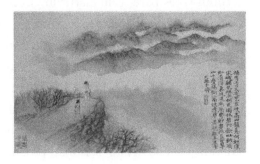

THE MOST CRUCIAL thing about this story of existence is that it knows itself to be mere story, as Lao Tzu and the Ch'an masters recognized, that it recognizes its own meaninglessness, its own vanishing. Only when we forget story and explanation are we returned to dwell here in the beginning, where empty awareness and the expansive presence of existence are whole, a single existence-tissue vast and deep, everything and everywhere. How strange that the story is most true when it falls silent. And yet, how liberating that we can

return to begin at the beginning in that silence anytime, anywhere. A simple room, for instance, morning sunlight through windows lighting the floor; a sidewalk cafe, empty wine glass on the table, trees rustling in a slight breeze, sunlit passersby; a routine walk through a park, late-autumn trees bare, rain clattering in fallen leaves. Or the mountain landscape in Stone-Waves' painting, where we share with Stone-Waves the culmination of his lifelong landscape practice. We walk to a mountaintop, face out across ridgeline beyond ridgeline, then close our eyes. We forget everything we know, all of the ideas and knowledge and assumptions about ourselves and the nature of things. We forget Lao Tzu's seminal poem, forget Inkstone-Wander's poem and Stone-Waves' painting, and continue on from there, forgetting all of the thoughts and memories defining us each as a center of identity. Here, we share this experience with Stone-Waves in the deepest possible way, for there is no longer any distinction between us as separate centers of identity. We forget this entire story of existence, and turn to the empty darkness that is our own awareness, which is all that remains after this practice of forgetfulness, and we inhabit the expansive space of that darkness.

We abide in that darkness for a time, then open our eyes. We look as if it were sight seeing for the first time, seeing things as they are in and of themselves, free of all our tenuous human stories about them, our ideas and beliefs. And there we find mirror-deep awareness and the ten thousand things filling that awareness, as it does

in any routine moment of mindful attention to immediate experience: the expanse of awareness and the expanse of existence returned to their original nature as a single tissue, the existence-tissue vast and deep, everything and everywhere. We gaze out into dark-enigma, even if it is drenched in sunlight: ridgelines trailed out kingfisher-greens and indigo-blues, sea-*ch'i* mist billowing through valleys and rising up mountain slopes, through abandoned orchards, seething up to erase broken walls and houses, a city in ruins, scatters of wild chrysanthemum-blooms fading against winter, unharvested pears and apricots, and soon the mountaintop where Inkstone-Wander stands.

Here in the beginning, existence rustles. From nowhere else, it occurs and occurs. It gazes out at itself, and it is whole. And as it is our most elemental identity, we too are whole. It is whole, but not complete, never complete. It is restless. It rustles, occurring and occurring. It wants to recognize itself, to orient, to celebrate. It wonders. It wants to know itself, to understand and explain, to decorate itself with story and meaning as if there were meaning. It is whole, and it wants to begin: *This is the story of existence, and it begins with a painting.*

PLATES

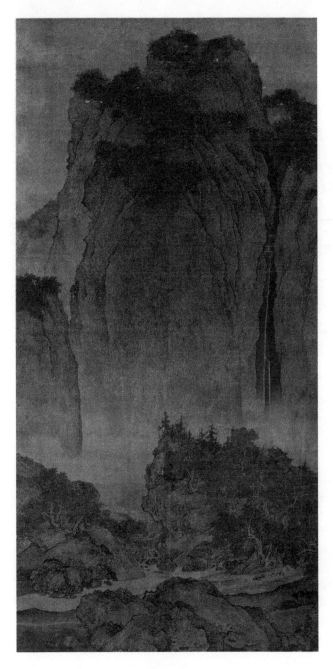

PLATE I

Fan K'uan (10th–11th centuries): *Travelers
Amid Streams and Mountains* (ca. 1020)

National Palace Museum, Taipei

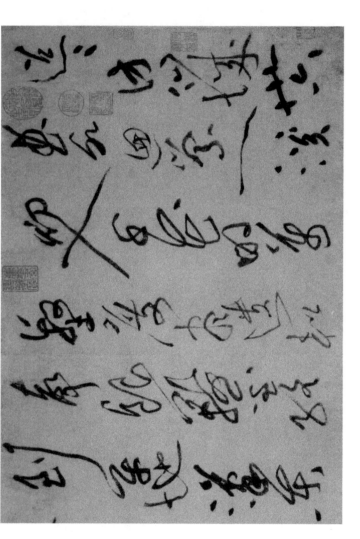

PLATE 2

Huang T'ing-chien (1045–1105): Li Po's "Thinking of Long-Ago Travels" (1094)

Yurikan Museum, Kyoto

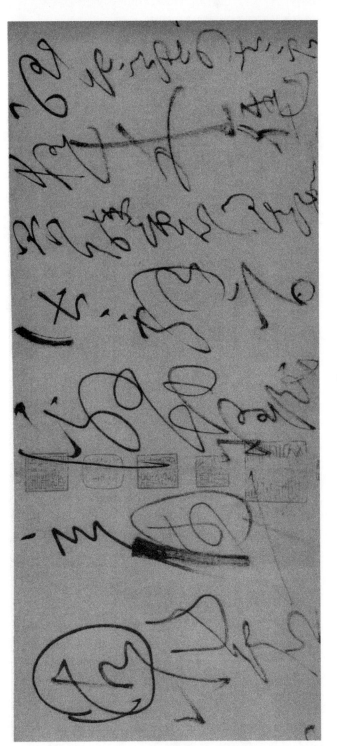

PLATE 3

Huai Su (737–785): *About Myself* (777). Detail.

National Palace Museum, Taipei

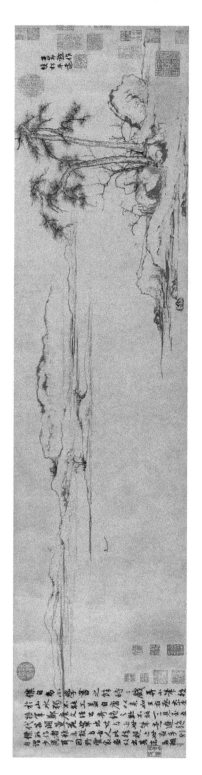

PLATE 4

Chao Meng-fu (1254–1322): *Twin Pines, Level Distance* (ca. 1310)

Metropolitan Museum of Art, New York

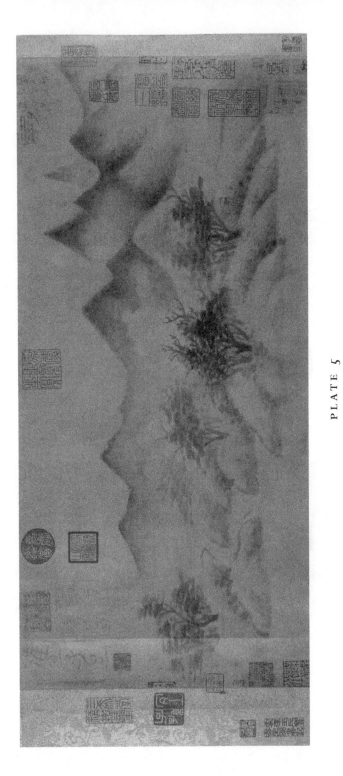

PLATE 5

Mi Yu-jen (1074–1151): *Cloudy Mountains* (ca. 1145)

Metropolitan Museum of Art, New York

PLATE 6

Hsia Kuei (12th–13th centuries): *Streams and Mountains,*
Pure and Remote. Detail.

National Palace Museum, Taipei

PLATE 7

Liang K'ai (12th–13th centuries): *Poet Strolling by a Marshy Bank*

Metropolitan Museum of Art, New York

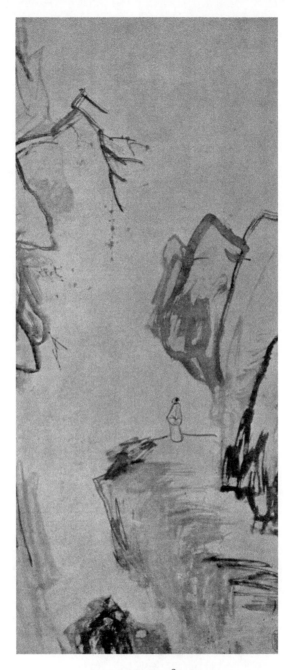

PLATE 8

Chang Feng (17th century): *Gazing at a
Red-Leafed Maple Across a Ravine* (1660). Detail.

Yamato Bunkakan, Osaka

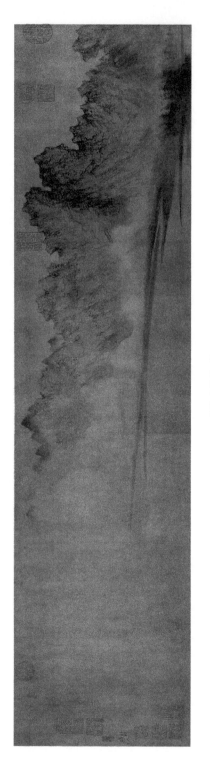

PLATE 9

Fang Ts'ung-i (14th century): *Cloudy Mountains* (late 1360s). Detail.

Metropolitan Museum of Art, New York

Sources and Further Reading

I

FOR THE CONCEPTUAL APPROACH OF THIS BOOK

(Books in order of relevance under each author.)

Jean François Billeter
 The Chinese Art of Writing (Esp. pp. 247 ff.)

Francois Cheng
 Empty and Full: The Language of Chinese Painting
 Chinese Poetic Writing

David Hinton
 Hunger Mountain: A Field Guide to Mind and Landscape
 Tao Te Ching (Also in: *The Four Chinese Classics*)
 Mountain Home: The Wilderness Poetry of Ancient China

François Jullien
*The Great Image Has No Form, or On the Nonobject
Through Painting
The Book of Beginnings
The Propensity of Things
In Praise of Blandness*

George Rowley
Principles of Chinese Painting

II

FOR SHIH T'AO

François Cheng
Shitao (1642–1707): La Saveur du Monde

Jonathan Hay
Shitao: Painting and Modernity in Early Qing China

Richard Strassberg
Enlightening Remarks on Painting by Shih-t'ao

Phil Dera

DAVID HINTON is author of the now-classic book of essays *Hunger Mountain: A Field Guide to Mind and Landscape* and many translations of ancient Chinese poetry and philosophy—translations that have earned wide acclaim for creating compelling contemporary works that convey the actual texture and density of the originals. These works have earned Hinton a Guggenheim Fellowship, numerous fellowships from N.E.A. and N.E.H., and both of the major awards given for poetry translation in the United States: the Landon Translation Award (The Academy of American Poets) and the PEN American Translation Award. The first translator in over a century to translate the five seminal masterworks of Chinese philosophy—*I Ching, Tao Te Ching, Chuang Tzu, Analects,* and *Mencius*—Hinton was recently given a lifetime achievement award by The American Academy of Arts and Letters.